# General Sherman
### and the
## *Georgia Belles*

# General Sherman
## and the
# *Georgia Belles*
## Tales from Women Left Behind

*Cathy J. Kaemmerlen*

Charleston · London

History
PRESS

Published by The History Press
Charleston, SC 29403
www.historypress.net

*Front cover image:* Courtesy of Frank Tarpley. His work can be found at www.georgiasunrise.com.
*Back cover:* William Tecumseh Sherman. *Courtesy Library of Congress.*

First published 2006

Manufactured in the United Kingdom

ISBN-10 1.59629.159.1
ISBN-13 978.1.59629.159.1

Library of Congress Cataloging-in-Publication Data

Kaemmerlen, Cathy.
  General Sherman and the Georgia belles : tales from women left behind /
Cathy Kaemmerlen.
     p. cm.
  Includes bibliographical references.
  ISBN-13: 978-1-59629-159-1 (alk. paper)
  ISBN-10: 1-59629-159-1 (alk. paper)
  1. Sherman's March to the Sea--Anecdotes. 2.
Women--Georgia--Biography--Anecdotes. 3. Georgia--History--Civil War,
1861-1865--Women--Anecdotes. 4. Georgia--History--Civil War,
1861-1865--Biography--Anecdotes. 5. United States--History--Civil War,
1861-1865--Women--Anecdotes. 6. United States--History--Civil War,
1861-1865--Biography--Anecdotes. I. Title.

  E476.69.K33 2006
  973.7'378--dc22
                           2006025856

This book is dedicated to Martha Ziebutski Kaemmerlen, our family matriarch, who has inspired and encouraged an ever-growing line of strong women.

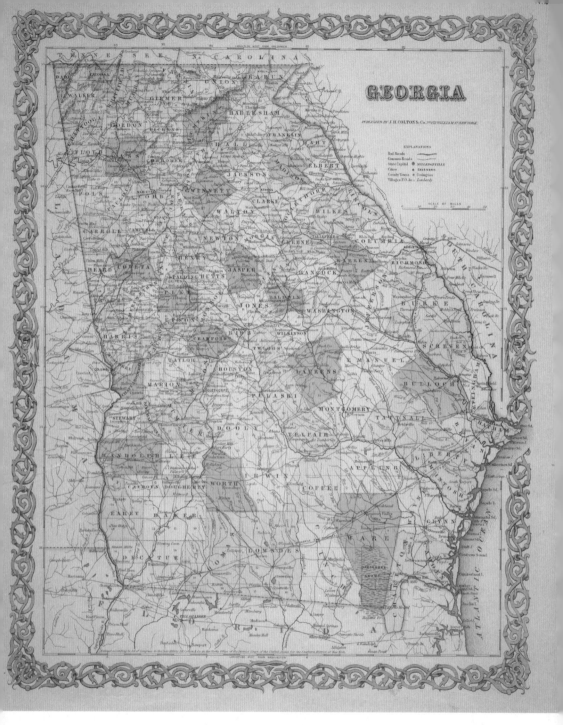

Map of Georgia, 1855. *J.H. Colton and Co., courtesy of the Georgia Archives Virtual Vault.*

# Contents

# *Contents*

# *Acknowledgements*

Special thanks to Jenny Kaemmerlen of The History Press, my editor and niece, for proposing and encouraging this project. Without her help it would not have gotten off the ground. To Erica Danylchak, research associate of the Kenan Research Center at the Atlanta History Center Archives; Dale L. Couch, senior archivist at the Georgia Archives; and Callie S. Campbell, information specialist for the Covington/Newton County Chamber of Commerce, all for much assistance in finding resources. Thanks to Steven Engerrand; Gail DeLoach (who is unbelievably helpful and available even though she's supposed to be retired); and Greg Jarrell, all of the Georgia Archives, for help in obtaining visual aids and the permission to use them from the Vanishing Georgia Collection. Thanks also to Amber Prentiss of the Hoke O'Kelley Memorial Library, Oxford College of Emory University and to the Troup County Archives. Thanks to Sherry Dudley of the Newton County Chamber of Commerce for help in researching the Covington Belles. Special thanks to Emily Roberts Gaare for the tedious job of going over the manuscript with a fine-tooth comb. Thanks to Julie Foster, editorial coordinator for The History Press, for her patience with a first-time author, and to the entire staff at The History Press for the work they do in publishing books out of the mainstream. Thanks to my family for all their support and patience. Special thanks to my husband, Robert Gaare, who serves as my sounding board, editor and advisor.

# "He Was Coming"

He was coming. It was not the second coming of Christ, but some believed it to be the devil himself. General William Tecumseh Sherman and his band of sixty thousand fiends had set on a sixty-mile-wide path of destruction through central Georgia's breadbasket, from mid-November to mid-December 1864.

Atlantan Mary Rawson, daughter of a city councilman, said, "Time after time we had been told of the severity of General Sherman until we came to dread his approach as we would that of a mighty hurricane." Some called him a giant octopus, with arms spreading his terror across the state.

Most Georgia women were to face the enemy alone—their men were off fighting or hiding for fear of being killed or taken as prisoners of war. As Martha Caroline Marshall from Monticello put it, "It was amusing to watch [the men] running when the Yanks were coming into town...I believed we would have given them everything if they had demanded it. You never saw people so frightened...for mercy sakes, make yourself behave, says I, you do like you are crazy—don't let them see you are frightened."

Women were frightened, for they heard horrifying stories that Yankees would cut off fingers to steal the rings off their hands and tear valuable earrings right from their ears. The Yankee demons would burn all their

homes and commit all sorts of personal outrages. This was the build-up to Sherman's March, in which he was self-charged with taking the stuffing out of the state of Georgia, which pretty much up to this point in the Civil War had been untouched. But now it was all different and time for Georgia to feel the pangs of the war.

Sherman and his army conquered Atlanta, were safely ensconced and had been for two months. But he pulled out of Atlanta, and instead of chasing after General Hood's Southern army to Tennessee, he decided to take on a risky venture, cutting himself off from the rest of the Union army, the supply trains and all communications. He was going to conquer the state of Georgia and live off the fat of the land.

Sherman had a vast knowledge of Georgia geography and correctly predicted there'd be little chance of his men starving as they made the three-hundred-mile trek across Georgia. There were yams and hams aplenty. His true objective of the march was to cause the inhabitants of Georgia (which meant women and children) so much suffering that their belief in the "cause" would be demoralized to the point they would demand an end to the war and a quick peace settlement.

Major Henry Hitchcock, Sherman's adjutant and right-hand man, put it thusly, "The only possible way to end this unhappy and dreadful conflict is to make it terrible beyond endurance." Sherman insisted, "I don't make war on women and children." In fact, there are instances of his humanity, especially in Savannah, at the conclusion of the march, when he provided provisions for homeless, desperate Georgia refugees. But he could exhaust Georgia's resources, prevent the women from feeding the Southern army and destroy citizen morale.

He called this a total warfare, but many say he lacked the true killer instinct. His was more a psychological warfare, which was new to this young country—warring against civilians. During the Revolutionary War, the British, especially in the South, conducted a more brutal form of total warfare. But this was the first instance of countrymen making war against fellow countrymen, making this an uncivil civil war. Sherman's goal was to bring our country back, unified, under one flag, and to use whatever means necessary to do this.

The women of Georgia braced themselves for an invasion by sixty thousand Yankees. It was not unusual in the antebellum period

in the South for a woman to be left alone on the plantation. Even the most privileged women worked harder than their equivalents in the North. With her husband's frequent absences, a Georgia wife learned to run the business and manage the household, including the slaves. It might have been a lonely life, but she learned to withstand the pressures, and was not often rattled. Home and hearth and family meant everything to her; and when those three things were threatened, the typical Georgia belle was well prepared, at least emotionally, to protect all that was rightfully hers. And she did this with a zealous passion that rivaled that of any female warrior—past or present, fictional or non.

In fact, some Georgia husbands worried that their wives' passion might go too far. They advised their women to be "polite" to the Yankees. Marcellus Stanley of Athens wrote to his wife, Mrs. Julia Pope Stanley, cautioning her to act with coolness toward the advancing Union army. "In these times we ought not to be surprised at any event, much less ought we to give way to vague apprehensions and exhibit to the world a ludicrous timidity." And these steel magnolias were far from timid where the Yankees were concerned.

"Hurrah for the ladies! They are the soul of the war," cried Bell Irwin Wiley in his book *Confederate Women*. Georgia belles spent anxious days preparing for the Yankee onslaught by praying, hiding their valuables in creative and crafty fashions and building up their courage for the invasion of the "wicked vandals." And when they came, the women unleashed their vehemence, protecting their havens with every ounce of courage and spirit they could muster.

According to some Yankee soldiers, Georgia women "talked too damn strong and did not deserve protection…some spit on us, threw stones at us, threw scalding water in our faces." One soldier tells a tale of dunking a Georgia woman in a barrel of molasses to sweeten her temper. Martha Caroline Marshall wrote of bands playing while the Yankees marched through Monticello. She responded: "I felt I could hang every Yankee in the Confederacy." About two hundred Yankees came for breakfast and offered to pay for their meals. She refused, saying their money was no good to her. When they left, she said, "I was so mad I could not help shedding a few tears."

It wasn't uncommon for a Georgia belle to say to a dying Yankee, "I would give you a cup of water to soothe your dying agonies and, as you are a Yankee, I wish I had the opportunity to do so." Women

like this were branded as "she-devils" by the Yankees and even blamed for prolonging the war with their zeal for the righteousness of the "cause."

When it came to hatred, it was generally thought that the Confederate female was more ardent and faithful to the "cause" than the Confederate male. For example, one woman spit out her words, saying, "Our men will fight you as long as they live and these boys'll fight you when they grow up. Take everything we have. I can live on pine straw the rest of my days. You can kill us, but you can't conquer us."

Sherman himself said there was no parallel to the deep and bitter enmity felt and expressed by the women of the South. "You women are the toughest set I ever knew. The men would have given up long ago but for you. I believe you would have kept up this war for thirty years...They talk as defiant as ever."

But on the other hand, there are the stories of the gentle magnolia belles, the softer side, the lovely women of Georgia who "tamed the Northern monster." It is said that there are two great beauties in the South—the women and the towns. Yankee soldiers often commented, "[there were] some real smart looking pieces. They were a feast to the eyes and refreshing to the soul." One soldier said, "The tastiest Secesh I've ever seen—with charm enough to melt the hardest of hearts." Folklore says that the lovely charm of a Southern belle caused the Civil War itself when the belle jilted Secretary of State William Henry Seward.

Colonel James C. Nisbet, who commanded a regiment of Georgians, mostly from the plantation class, summed up the strength of these women, paying a tribute to them with the following words: "It is upon the women that the greatest burdens of this horrid war fell...she dwelt in the stillness of her desolate home...may the movement to erect monuments in every southern state to our heroic southern women, carve in marble a memorial to her cross and passion."

Stories of these steel magnolias as they faced, often alone, a vast invading army intrigued me and inspired me to write this book. Who knows what any of us will do when put to the test, when we are forced to draw from our innermost reserves and make choices about what it is that is absolutely most important to us? What does it take for someone to cross the line, forcing a delicate magnolia

to turn to steel? Whatever the belief or cause, what does it take to defend, defying all odds, what is most dear and precious to us? On behalf of all these women, our steely soft ancestors, matrons and role models, with this book I carve in *paper* a memorial to their cross and passion.

# The Occupation
# of Atlanta

Back in the 1860s, Atlanta was called the Gate City of the Confederacy. Next to Richmond, Virginia, the capital, Atlanta was the second largest city in the Confederate States of America. It was the railroad hub and supply central to the troops and citizens alike.

In the summer of 1864, the Confederate troops under Joseph E. Johnston were retreating from Kennesaw Mountain. Federal General William T. Sherman, with his flanking maneuvers and his army twice the size of Johnston's, forced the Confederates to fall back and regroup around Atlanta. They were bracing for a major offensive attack. From late July until late August, Atlanta was shelled from both sides. It was said that the Confederate forces, now under General John Bell Hood (Confederate President Jefferson Davis ordered Johnston replaced), were entrenched too close to the city lines, making the city feel the effects of the constant bombardments.

On August 31, the Union troops cut off the city's rail line at Jonesboro, forcing the Confederates to evacuate Atlanta. On September 1, Sherman said, "Atlanta is ours and fairly won." With the occupation of Atlanta by the Federal army, a panic ensued. Sherman ordered Atlanta evacuated of all its citizens, in an attempt to put women and children out of harm's way. "God will judge us

in due time, and he will pronounce whether it be more humane to fight with a townfull of women and the families of a brave people at our backs, or to remove them to places of safety among their own friends." Many people had no place to go, becoming refugees, living in empty railroad cars, eating nothing but yams.

Sherman was changing his war strategy. Figuring the war had gone on long enough, his strategy was evolving into what he called a "total war" campaign, to bring the South to its knees. Anyone, citizen or soldier alike, contributing to the war effort must be stopped.

The mill towns had already been evacuated, the mills were burned and some eighteen hundred mill workers (mostly women and children) were charged with treason for making cloth for the Confederate cause and shipped north across the Ohio River. They were the first victims of this total war campaign and probably suffered the harshest punishment.

This was serious business—bringing the South to its knees. Many were already feeling the effects of Sherman's torch. The following six accounts by women of all ages, in and around Atlanta, describe the pre-march panic.

## MISS A.C. COOPER: REFUGEE

*"To arms! To arms!" was the shout that woke the echoes in the sweet Southland and, answering that call, poured forth the Southern men, and even boys—eager for the fray...There was not, at first, much serious thought about it. It was only a frolic, a playing at war...*

*Darker and darker grew the clouds. Sherman marched into Georgia...Run and flee, hurry, scurry, run here and there, burying treasures like syrup and not necessarily gold and silver, but pieces of homespun jeans and factory cloth intended to be made up for the soldiers and home knit socks, pieces of bacon...It would have been laughable if not so pathetic...Sherman is coming and we lay in the course of his march...like a huge octopus he stretched out his long arms and gathered everything in, leaving only ruin and desolation behind—not 20 men all told to protect us and no place to flee because the army spread for miles...*

*I wonder if these men suffered more than the women who remained at home and fought life's battles silently.*

# The Occupation of Atlanta

## CARRIE BERRY: TEN-YEAR-OLD DIARIST

In July of 1864, Maxwell Rufus Berry came home to his Atlanta house on the corner of Walton and Fairlee Streets, bringing with him a blank notebook. It was his intent that his oldest daughter, Carrie, then nine, document what was going on in the Gate City to the Confederacy during the summer of 1864. According to Father Berry, someone in the family should keep a day-to-day diary of the shelling by Yankees and Confederate soldiers alike during the hundred-day siege of Atlanta. This was history in the making. Carrie, being the oldest, most dependable and most likely to keep a daily account, was the chosen one. She took on the job, some days with all the joy that goes with a school assignment, but she persevered. Today we treasure her daily reports that give us insight into the terror from friendly and unfriendly shelling on their property and that of their friends and family for three hard months.

She made her first entry on August 1, 1864. "Gen. Johnston fell back across the river on July 19th and up to this time we have had but few quiet days. We can hear the cannons and muskets very plane [*sic*], but the shells we dread." Several days later she wrote of celebrating her tenth birthday with a day of ironing, but no cake. Those were hard times and flour and sugar were luxuries. She went on to write about shells that exploded in the backyard, sending Carrie and sister Zuie rushing to their cellar "bombproof." And she included the time a shell fell through the roof and landed on the little bed next to her mother's. Fortunately they were out for the evening. Another time a piece fell through the roof, landing in their dining room. It didn't take long for one out of every three houses in Atlanta to suffer damage. But the Berrys stayed in Atlanta, even when Hood's troops evacuated and Sherman's troops marched in. The edict was issued: the whole town must be evacuated, for the safety of all those involved. Carrie's mother was expecting her sixth child and did not want to leave. They had no place to go, anyway. As Carrie put it, "this broke into all our arrangements."

However it did not take her resourceful and Union-sympathizing father long to secure a position with the Southern

Express Company, making him a viable candidate to be of service to the Feds. Maxwell Berry never enlisted in the Confederate army, being one who did not believe enough in the institution of slavery "to die for it." Plus he had a "problematical stomach" as Carrie put it. His baby brother Oscar fought for the CSA and was killed in Decatur, Alabama. Another brother, John, enlisted and survived the war. His parents lived on a farm near McDonough, Georgia. The farm was raided by Sherman's troops, who took all the livestock and feed. Not many people had enough to eat.

Carrie watched as neighbors and her dearest friend, "Auntie Healy," vacated the city, as the last train left Atlanta. In the weeks to follow, she wrote of the loneliness and dreariness as she filled her days with knitting, looking after her sisters, ironing and writing in her diary. Then in November the Federal troops left to start the march, leaving a good portion of Atlanta in ashes. She wrote of her fear that the Yankees would come burning their house too. "They behaved very badly." But her father secured a guard, so their house was not torched.

It took a while for the city to "bounce back" and for its citizens to return and rebuild. After the Yankee pullout, Carrie did not write as frequently in her diary. The drama had passed and the war was dying down. In June of 1865 she wrote, almost squealing with delight: "Oh what good news happened this morning. Auntie Markham [her real aunt] and Cousin Emma came home. Oh me I was so glad." Atlanta was picking up the pieces.

Carrie went on to marry William Crumley, seven years her senior, produce four children and live the rest of her days in Atlanta. She's buried at Oakland Cemetery in Atlanta in the Crumley family plot, close to the entrance. It is often visited by curiosity seekers who know of her diary, owned by the Atlanta History Center and on permanent display there. Some have even gone so far as to call her Atlanta's Anne Frank. Segments of her diary have been featured in a book called *A Confederate Girl: The Diary of Carrie Berry, 1864*, edited by Christy Steele with Anne Todd, part of a series of titles for young readers about diaries, letters and memoirs.

## Mary Ann Harris Gay of Decatur: Georgia Woman of Achievement

It was a sad time, the summer of 1864, for ardent Confederate Mary Ann Harris Gay of Decatur, Georgia, as the news came that the Yankees had crossed the Chattahoochee River. There was nothing to prevent them from advancing on to Decatur. In preparation for the Yankee onslaught and the inevitable surrender of Atlanta, Miss Gay and her twice-widowed mother filled their trunks with the family china, cut glass, treasured relics, important papers and bedding, and prepared them for shipment the next morning via freight train from Decatur to Atlanta. They were taking their valued possessions to the home of Mr. McArthur on Pryor Street in Atlanta, who had a safe space, but no means of transfer from the train station. They would have to find another way to transport their belongings.

How to get the trunks to the McArthur house—no easy feat since there was a vast shortage of horses and carriages in those days. Never a defeatist, Mary Ann found a wheelbarrow and, with the help of a servant, took one trunk at a time to the McArthur house. This was but one example of the application of her philosophy of life. In her own words, "In all the walks of life, it has been demonstrated that pluck and energy, and a firm reliance upon Providence, are necessary to surmount difficulties, and of all these essentials I had a goodly share."

Entrusted in her care was an assortment of winter clothing owned by Confederate soldiers. She needed to devise a means of concealing all these items before the arrival of the Yankees. She had no intention of jeopardizing her mother's home. If the Federal troops found evidence of her aiding and abetting the enemy, they would surely burn the house down as punishment. So she proceeded to hoist herself up on a table, placed a chair on the table to stand on in order to reach the ceiling and began making a small hole in the ceiling, using a hammer and chisel. When the hole was big enough to insert her fingers, she cracked and weakened the plaster enough to pull off some larger pieces. She laid the box lids of the clothing cartons across the joists to make a floor. This created improvised shelves upon which she could lay articles of clothing. Then she replaced the laths and moved a ceiling-high dresser to conceal the missing plaster. But now she was faced with the task of removing the

chunks of removed plaster and resulting dust. If the Yankees found plaster chunks around the house or yard, this would immediately arouse suspicion. So she carefully broke and pounded the plaster into very small pieces, filling every vessel and basket in the house with the results. At night, when the coast was clear, she emptied the vessels into an old dirty ash hopper. Removing the dust was a more tedious affair, involving the use of multiple rags and flannel cloths.

When the time and need came for her to remove the clothes and return them to the needy Confederate soldiers, she met this task with equal cunning. During the night, she undid her work and then proceeded to put the clothing into sacks she got from the Yankee camps. Mary Ann was always a thrifty person, finding a use for everything. These were crocus sacks used in the transportation of grain. She shook them out thoroughly and found balls of twine and some large needles to sew the sacks shut. She obtained permission to travel to Augusta to see her sister, who would take the articles of Confederate clothing and distribute them to their rightful owners. On her trip to Augusta, Mary Ann remembered one precious hand-knit scarf she'd left behind, one lovingly knitted by her brother's wife. Her own brother David was one of the Confederate soldiers in need of warm winter things. It was too late to go back for the scarf. Shortly thereafter her brother was killed.

Mary Ann called William T. Sherman the Nero of the nineteenth century—the leader of the most ruthless, godless band of men ever organized in the name of patriotism. And this was probably her highest compliment to him. After Atlanta fell into Union hands, there were ten days of armistice before Sherman declared that Atlanta must be evacuated. Ever the clever entrepreneur, Mary Ann and her mother were allowed to stay, as they did washing, ironing and darning for the Yankee soldiers, "for reasonable prices," as she said.

The Union cavalry set up camp outside her home for three long months, commandeering her parlor for their Decatur headquarters. But having the enemy outside and inside alike would not stop the undaunted Mary Ann Harris Gay.

She hoodwinked the encamped Yankees many times. Once she lined her petticoats with Northern newspapers, taken from the Yankee camps—the *New York Daily Times*, the *Cincinnati Enquirer*, the *Philadelphia Evening Ledger*—layering them to give her a "stylish

bustle." Having secured permission to leave town, she happily presented the stolen news to a grateful Confederate, Major Rank.

To keep from starving during the Yankee occupation, she picked out grains of corn from the cracks and crevices in bureau drawers and from improvised horses' troughs. She found about half a bushel of corn from the deserted campground of General Garrard's cavalry, USA. She washed the corn, dried it and then ground it into cornmeal. She made coffee from parched okra seeds. Her philosophy was put to use again. "All this struck me as the willing sacrifice of a peerless people for a great principle."

And in Christmas of 1864, after the Yankees marched out of Decatur and were on their way to Savannah, she heard the Confederate commissary was exchanging food for lead. She took a pail to where General Hood had destroyed an ordnance train in September and, using a dull knife, pulled bullets (probably Minié balls) out of the ground until her hands bled and her feet were frozen. This was called "working the lead mines."

The saintly Mary Ann Harris Gay, known to one and all simply as "Miss Mary," shared what she gleaned, found, made and bartered for with less fortunate families, often walking for miles to exchange food and provisions. It is no wonder that a Federal officer declared to her, "I glory in your spunk and am proud of you as my countrywoman."

Her book, *Life in Dixie during the War*, was written as a tribute to her brother David, who was killed during the last few months of the war, and written so that his son could appreciate the father he never knew. It was apparently so inspirational to Margaret Mitchell that she drew upon stories from this book to use in her own classic book, *Gone with the Wind*. Perhaps Scarlett herself was partly modeled after the goodly share of "pluck and energy" possessed by Miss Mary Ann Harris Gay, who lived to be ninety years of age.

## Minerva Leah Rowles McClatchey of Marietta

Minerva Leah Rowles was born in Maryland on the Mason Dixon line. When she married Wylie Jarrett McClatchey, they moved to Athens, Tennessee, where their family increased steadily in numbers. As civil war approached, the McClatcheys felt there were

too many Union sympathizers and too many abolitionists in Athens who tended to look down on them as slave owners. So they moved to Marietta, Georgia, where their sons could attend the Georgia Military Institute.

As war broke out, Minerva's oldest son John enlisted in the Confederate army. Her youngest son, William Penn (named after her famous maternal ancestor and founder of the Quaker colony named in his honor), was still a cadet at GMI and too young to fight. Her husband, ardent secessionist that he was, was physically unable to serve in the army, lamed from a broken hip from before the war.

Her ordeal with Sherman and the Union army lasted seven months, stretching from May through mid-November of 1864. In May, troops on both sides were amassing for a major battle in the Kennesaw area, just to the north and west of the McClatcheys' Marietta plantation. She didn't doubt soldiers wearing gray and blue coats would soon appear in all outlying areas. Husband Wylie stayed at home as long as he could, but with the approach of Sherman's army, he finally packed up the family silver and most of the slaves and moved to middle Georgia. Minerva was determined to stay on their plantation and close to her youngest son, still a cadet. She heard that it was the vacant homes that were the ones more than likely to be destroyed or desiccated and knew it was safer for her to stay than for her husband. Nineteen-year-old Devereaux, who had lost three fingers on his left hand in a mill accident and thus was ineligible to serve in the Confederate army, stayed behind to help his mother.

Minerva was a gifted writer, as evidenced in her sprightly journal accounts. She wrote: "We feel as if the enemy is almost at our door," and they were. A regiment of the Confederate cavalry skirmished with Union forces in her backyard. The soldiers in blue almost shot Devereaux. Spotting him, they cried, "Here's one in the house." Minerva immediately ran to his defense. In five minutes' time it seemed to her as if "all creation was in and around the house and dressed in blue."

A Federal officer said, "You must get in the cellar." But they had none to escape to. So he retorted, "Well then get behind those large trees." The Yankees made their breastworks and battery by the McClatchey stables. There was a skirmish and two Federal

soldiers were killed and buried near the house. Several more had amputations performed on the grounds.

Later on Federal General Joseph Hooker entered the house, shook Minerva's hand and said he was glad to see a neighbor at home, as most of the houses were deserted. He was glad she didn't believe in those tales of Yankee cruelty and said that his soldiers recognized a woman's right to stay at home. He finished in saying, "You have acted wisely and will be well protected. We did not come to war with inoffensive citizens but to preserve the Union."

A Federal soldier played the family piano, located in the parlor. He hadn't seen a parlor, he said, or a piano, in six months and played zealously. She protested having music and dancing on the Sabbath. The soldier replied he never knew what day of the week it was anymore and apologized for breaking the Sabbath and offending her.

No more soldiers entered her house, but they did take everything they could from the storeroom and outer kitchen, killing fowls, leaving baby chicks motherless, taking the cow and cooking vessels and even the children's books. They beat the green apples from the trees before they were ripe, tramped through her garden and cut down the field of corn.

Minerva thought, "If this is the way they do it in the daytime, what may we expect tonight?" She was given two soldiers to stand guard through the night.

On July 20 there were still more soldiers coming through. She kept company with them on the back porch, trying to prevent them from entering. Devereaux was very sick and she had no medicine for him. Her only comfort was in the thought "God's promises never fail."

Two days later, more soldiers came asking for her chickens. Minerva said she was saving them for her sick son. They were offended, saying she'd probably be more than willing to give them to Rebel soldiers. But still they sent word back to their company doctor of her ill son and returned with medicine. She could pay them only in Confederate money, which they said was worthless. A plain piece of paper had more value.

Minerva received news that her son John had been wounded in Virginia on June 11, 1864, and died a month later, on July 11. In a poignant moment of overwhelming grief, she went to the grave of one

of the Federal soldiers who had been buried on her land and wept for him, as his mother would have. She secretly hoped a mother in Virginia would do the same for her son. Now she knew what it was like to have a child cruelly wounded, die away from home and be buried in a distant plot. There can be no greater pain.

By mid-November, the Federal troops were pulling out and burning any war-making equipment they had to leave behind. She could see the flames of Kennesaw and the Georgia Military Institute. Kennesaw Mountain itself looked like it was on fire. The burning railroads looked like a "fiery serpent stretching out in the darkness." The fires came close to her stable and house. She fought hard to save the house and managed to do so in spite of the high winds helping to spread the flames.

She watched shamefully as citizens and refugees plundered what the Yankees left behind—or did not find—and wondered, *How much lower could mankind sink?* Her husband managed to return home safely, avoiding Sherman's army, typically hard on refugees, thinking them cowardly. Her youngest son, William, at fifteen, was mustered off to fight during the last desperate months of the Confederacy, captured at Kingston, Georgia, but later paroled.

Minerva died in 1880 and was buried in Marietta, perhaps on a site close to the Yankee soldiers who died on her land in 1864.

## SYNTHIA CATHERINE STEWART OF NEW MANCHESTER

Walter Washington Stewart, age twenty-two, married Charlotte Elizabeth Russell (Lizzie), age fifteen, and moved his new bride to the mill town of New Manchester, Georgia, where he became a boss man at the cotton mill on Sweetwater Creek. It was a state-of-the-art mill, named after the famous textile mills in Manchester, England. Not even nearby Atlanta, the Gate City to the Confederacy, just twenty-five miles to the east, had such a tall building. New Manchester mill workers bragged about making the best cotton osnaburg cloth around—far better than that made at the rival mill in Roswell.

Walter and Lizzie had four children by the time the Civil War started; a fifth came in September of 1861. They named that son Jefferson Davis Stewart in a show of Southern patriotism. The previous son was named James Buchanan Stewart, in a different

show of patriotism. Daughter Synthia, born in 1854, documented her Civil War experiences when she was in her nineties, living in Texas. Part of her story follows.

In late summer of 1860, Synthia Catherine Stewart held onto her father's hand as they walked the mill path to town. It was dark and everyone was headed to a show in town. As it turned out, Mother Nature put on a better one. There was a meteor shower that lasted about thirty minutes. Everyone covered up their lantern lights so they could fully admire the effects. Synthia looked in wonderment, but her father turned white and grew quiet. She asked, "What does this mean, Papa?" He replied, "It means the coming of war."

The meteor shower indeed foreshadowed the approach of the Civil War. Father Walter enlisted in the Campbell Salt Springs Guard, Company K, 41st Regiment, Army of Tennessee, and was off, to what he thought would be a brief war. The mill switched to making gray cloth for the Confederate army, some men staying behind to keep it running. Synthia's mother did accounting at the mill to help make ends meet.

Then the Yankees came, in July of 1864, quietly and without resistance. There was no one left in town who could provide any sort of defense. At first the townspeople were told to go home and pack their belongings, as they were being shipped out. Fighting would more than likely occur in the area and they were being removed for their own protection. In the meantime, General Sherman began his total warfare campaign, in an effort to bring the South to its knees and to undermine Southern morale. Eventually this meant warring against civilians, in particular those who maintained their loyalty to the Confederacy and those who provided support of any kind to the Southern cause. The mills, of course, were doing just that, in making cloth for the Confederate army. Mill workers were charged with treason and were the first to fall as victims of this total warfare campaign.

The New Manchester Mill and store were burned; nearby houses were spared. Then the mill workers were ordered to assemble at Ferguson's Crossing to wait for wagons to take them to Marietta. Synthia was allowed to bring one special remembrance from home to take on the journey. She chose the family Bible. This choice, according to family folklore, brought her face to face with General William T. Sherman himself.

A Union soldier helped the Stewart family settle onto the wagon. Most people had to walk to Marietta—a good fifteen miles away. The Stewarts considered themselves lucky. This soldier took Synthia's Bible until she got settled—at least so she thought. But he did not give it back to her. She studied his face and vowed to get the Bible back, in time.

The time came when they arrived in Marietta at the Georgia Military Institute, where mill workers from all over the state were being assembled. As prisoners of war, they were to be placed on trains taking them across the Ohio River. Synthia recognized the soldier who had taken her Bible, stood up in the wagon and started shouting, "He's the one who took my Bible! Somebody stop that Bible thief!" Her mother tugged at her sleeve to get her to sit down, but she would not stop her yelling until people paid attention to her pleas. She was waiting for someone to bring back her Bible. According to Synthia's obituary, it was none other than General Sherman himself who was the one who fetched the Bible from the Union soldier and personally returned it to her. After that Synthia was satisfied.

The family was taken to Louisville, Kentucky, and placed in the hospital prison, where all the mill workers remained until they signed the oath of allegiance to the Union. Once they signed the oath, they were allowed to cross the Ohio River and find work in mills in Cannelton, Indiana, and elsewhere.

Synthia's story took a miraculous turn when her father, Walter, was seen marching through Louisville as a prisoner of war. He had been captured outside Atlanta and was on his way to Camp Chase in Columbus, Ohio, when his family spotted him outside their Louisville prison. The family was allowed a brief reunion. Mother Lizzie found new hope, signed the oath of allegiance, moved the family to a boardinghouse and began doing accounting work for the Union while Synthia attended school. Walter survived the prison camp and returned for his family in Louisville when the war ended. Eventually they returned to New Manchester, only to find it a ghost town. They moved to Alabama a year or so later. Synthia later married David Boyd, moved to Texas and had nine children.

Synthia, also known as Granny Boyd, documented her war experiences to her grandson, Archie Grady Elwood Boyd, when she was ninety-two years old and living in Sidney, Texas, in Comanche

County. This gramophone family recording has been preserved and treasured by the Friends of Sweetwater Creek, the Atlanta History Center and by this author.

## Zora Fair: Oxford's Confederate Spy

Miss Izora M. Fair, of Charleston, South Carolina, like so many Southerners frightened by the likelihood of enemy invasion, fled with her uncle, Abram Crews, to the safety of Oxford/Covington, Georgia, some forty miles east of Atlanta. Abram was a blockade-runner for the large mercantile firm of Johnson, Crews and Brawley and wanted to see his family safely settled in middle Georgia. His niece, Zora, age unknown but described as a "young girl," had been entrusted to his care and accompanied the family to Georgia. The family settled into the Gaither/Payne house on Asbury Street, thanks to the friendship of William Capers, who found this house for his friend Abram and other area houses for more refugees.

Zora became friends with William's daughter, Susan Capers Stone, and spent many hours talking of their mutual fervor for the "cause" and love for the Confederacy. Every day Zora went to the railroad station at Covington to wave to the Confederate soldiers passing through on their way, she thought, to conduct various feats of bravery in the name of the Confederacy. She often visited nearby hospitals to comfort brave, wounded soldiers. But could she not do more, living a seemingly useless life of comfort and ease?

Atlanta soon fell to the Federal troops. The South Zora knew and loved would never give way to defeat and would never be subjugated by the North. In early November 1864, she resolved to prove herself useful. She'd disguise herself as an old Negress, infiltrate Sherman's camp and learn of his plans. Once these plans were found out, she'd relay the information to General Joseph Johnston, back at his home in Lincolnton, North Carolina.

She borrowed the necessary outfit from an old Negress, cut off her long brown hair and crimped the ends. She stained her face, neck and arms with walnut juice, to make herself look like a mulatto. She put on a big bandana to hide the rest of her hair, put on an old tattered shawl, bundled herself up with many layers to look heavy set and put rags in her mouth to make her face fuller and to help

disguise her voice. She had heard the Negro dialect all her life and didn't need much help to come up with a convincing enough voice. Now she looked and sounded the part and all that was left was to convince the Yankees.

It was a forty-mile walk to Atlanta from Oxford. She walked through the night and, at one point, on her hands and knees to get across a burned milldam. A sympathetic man gave a short wagon ride to "the old darkey woman." Finally she reached Sherman's picket lines and told the sentries she was an old slave woman, looking for her husband, who had run away to join up with Marse Sherman's army.

She was permitted to pass, reaching Sherman's headquarters at the Leyden House on Peachtree Street. Begging to be let in, she was allowed to sit and wait for him. General Sherman was in an adjoining room, making war plans, some of which she overheard. She heard him say he was evacuating Atlanta of all its citizens because of the likelihood the city would be set on fire. And he was planning a march to the sea, across the heart of central Georgia, where he would meet little resistance, facing only women and children left to guard the homefront. This march would certainly go through Covington and Oxford, where her friends and family now lived. She had to get the word out.

She hurriedly left Sherman's headquarters without having spoken with him and shouted the password to the pickets, who started firing at her when she would not halt. Evidently they were firing only warning shots because, unharmed, Zora fell among the weeds at the roadside, waiting to see if someone would come after her. When no one did, she crept out of sight and then started the walk back to Covington. In three days' time she had walked eighty-two miles, her feet now swollen and blistered, but arrived home safely. She hoped she was in time to put out the warnings about the oncoming Federal troops.

She surmised that when General Johnston became aware of this intended march, he'd prepare a defense. She wrote him every detail she'd overheard and signed her name, then posted her letter. The Federals at this point were checking every mailbag, censoring both intended and unintended espionage, and easily found Zora's letter. The innocent, peaceful town of Covington was harboring a spy and they knew right where to look for her.

# The Occupation of Atlanta

Accounts of what happened next differ here. Some say Zora successfully hid in the attic of the home at Asbury Street. Some say she didn't need to hide at all because the spy they were looking for was an old Negress woman. Most say that she fled to the Rock, a romantic spot two miles from Covington, where couples had gone before the war for a trysting place. She was afraid the Federals would burn down the house where she'd been living and now hiding in, and punish her family and friends for harboring a spy. She herself would probably be hanged for her actions. She hid out by the Rock during the day and spent her nights at nearby farmhouses. After three days of looking, the Federals gave up the search and Zora returned home safely. The news by then had spread that Sherman and his Federal army were coming. In the streets, children played "the Yankees are coming" games, playfully imitating the serious concerns of their parents. Sherman came to Covington/Oxford on November 16. Neither General Joseph Johnston nor any other Confederate general came to stop him.

It was a cold and bleak November in Georgia. Being out in the elements for three days and nights had made Zora physically ill, but worse than that was the damage to her spirit, irreparably crushed. She returned home to South Carolina and died in Orangeburg a few months later.

Her story lives on. At the Gaither/Payne house at 1005 Asbury Street in Oxford, Georgia, on the campus of Oxford College of Emory University, stands a plaque honoring her, summarizing her spying adventures for the Confederacy, and calling her "Oxford's Confederate Spy."

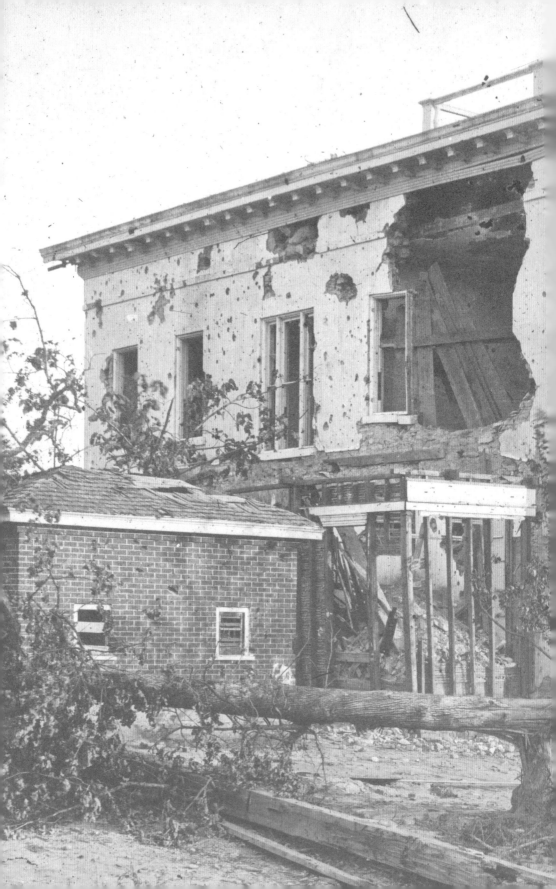

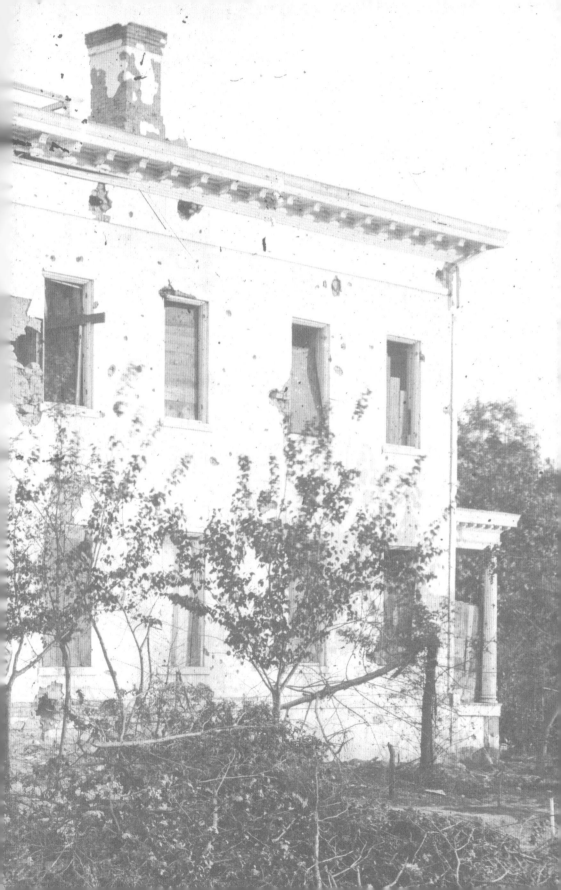

*Chapter 2*

# The March Begins

On November 8, 1864, Sherman was in Kingston, Georgia, eagerly awaiting a telegram from General Ulysses S. Grant. He was looking for a reply to his request to begin a three-hundred-mile march across the state, a march that would cut him off from the rest of the Union army and all communications for about six weeks. He would not pursue General Hood's forces into Tennessee. Instead he would attempt to live off the rich Georgia land, destroy what he didn't need and leave behind a devastated state, devoid of resources and the spirit to continue the war. The telegram arrived that day, giving him his permission.

Sherman weeded out the old, the wounded and the frail, trimming his army to sixty thousand of the fittest and finest to take on this march. His men put the torch to Atlanta, destroying anything of value to the war-making effort. Then on November 15, after occupying Atlanta for almost three months, Sherman and his army of sixty thousand formed two wings and marched out of Atlanta.

The Union army advanced at the rate of ten to fifteen miles a day, stretching out in a sixty-mile-wide line, with "octopus arms" affecting an even larger chunk of middle Georgia. Some of the towns and plantations that were struck were among the most beautiful in Georgia: Madison, Monticello, Covington.

Sherman instructed his men, called "bummers," to take what they needed "on the outside," but not to destroy or plunder the homes themselves. The bummers and foragers had a heyday, filling their arms full of the plenty that came from middle Georgia. It wasn't unusual for a soldier to have a ham stuck on a bayonet carried in one hand, a honeycomb dripping from the other, a chicken or two under his arm and his haversack full of yams. These men hadn't feasted like this in a long time. Middle Georgia provided enough goods for many a picnic. The soldiers looked on this venture as one giant party, a reward for all the sacrifices and horrors they had witnessed on the battlefields for over three years.

The women were told to be prepared—to hide whatever valuables they could, to lock up or hide the livestock and to start praying. They had no idea these Yankees would come through like army ants. For the most part the main houses on plantations were spared, but the outer houses were not. In town the houses were plundered, but more than likely not burned unless there was resistance or the home belonged to a higher-up in the Confederate ranks.

Included here are five stories of women from Covington to Madison, towns affected during the first week of the march. Added are several collections of miscellaneous hiding stories. "They will long remember Sherman, marching to the sea."

## THE MARCH TO THE SEA

*The foragers through calm lands*
*Swept in tempest gay.*
*They breathed the air of balm-lands*
*Who should say them nay?*
*The regiments uproarious*
*Laughed in Plenty's glee.*
*They marched till their broad laughter*
*Met the laughter of the sea;*
*It was glorious glad marching,*
*But ah, the stern degree.*
*That glorious glad marching,*
*That marching to the sea.*
*The grain of endless acres*
*Was threshed as in the East*
*By the trampling of the Takers,*

# The March Begins

*Strong march of man and beast.*
*The flails of those earth-shakers*
*Left a famine where they ceased.*
*The arsenals were yielded;*
*The sword that was to be,*
*Arrested in the forging,*
*Rued that marching to the sea.*
*It was glorious glad marching,*
*But ah, the stern degree!*

*For behind they left a wailing,*
*A terror and a ban,*
*And blazing cinders sailing,*
*And houseless households wan,*
*Wide zones of country paling*
*And towns where maniacs ran.*
*Was it treason's retribution—*
*Necessity the plea?*
*They will long remember Sherman*
*And his streaming columns free—*
*They will long remember Sherman*
*Marching to the sea.*

*Herman Melville*

## ALLIE TRAVIS OF COVINGTON

Covington, Georgia, was, and still is, a beautiful Southern town of many graceful old homes. When Sherman's army came through on November 17, 1864, the roses and dahlias were in bloom. Even soldiers hardened by over three years of bloody warfare could not help but notice the beauty.

Sherman, met on the outskirts of town by Covington's mayor, informed the mayor that everything inside the houses was to be respected and left alone, but everything on the outside belonged to Uncle Sam. This was an order that was not strictly obeyed or enforced throughout the march.

Allie Travis watched a moving mass of blue coats pass her house from early morning to late at night. She watched Yankees chase down

## Sherman's Letters Home: My Dearest Ellen

Sherman wrote this letter to his wife, Ellen, at the start of the march; it was to be his last communication with her until the march ended.

*Gaylesville, AL. Oct. 27, 1864*
*Dearest Ellen:*

*I've got my wedge pretty deep and must look out I don't get my fingers pinched. Where a million people find subsistence, my army won't starve. I can make the march and make Georgia howl. If the people raise a howl against my barbarity and cruelty, answer that war is war and not popularity seeking. If they want peace, they and their relatives must stop war. The Southern people cannot be made to love us, but they can be made to fear us and to dread the passage of troops through their country. It is a paradox, but the most humane way to end this war is to bring the south to its knees. It's a big game but I can do it, and I am too red headed to be patient.*

*Affectionately yours,*
*Sherman*

## SHERMAN'S SPECIAL FIELD ORDER # 20
### (ABBREVIATED VERSION)

*The army will forage liberally on the country during the march. To this end, each brigade commander will organize a good and sufficient foraging party, under the command of one or more discreet officers, who will gather, hear the route traveled… whatever is needed by the command, aiming at all times to keep in the wagons at least ten days' provisions for his command, and three days' forage. Soldiers must not enter the dwellings of the inhabitants, or commit any trespass; but during a halt or camp, they may be permitted to gather turnips, potatoes, and other vegetables, and to drive in stock in sight of their camp. To regular foraging parties must be entrusted the gathering of provisions and forage, at any distance from the road travel.*

chickens. They had to pull out of formation to run down the hens. At first the chickens stayed in or near the hen house, making them easy to catch. But when the chickens were frightened and tried to flee, it was difficult for the Yankees to corner them. They came after the squawking hens with clubs and sticks. It provided a comic relief to an otherwise frightening blue-coated parade of enemy marauders.

Allie's mother put two of the family's turkeys in the closet, where they kept quiet enough to escape "Yankee rapacity." But she feared that Allie wouldn't keep quiet if pushed too far. Her strong Rebel sentiments were well known. So she made the highly opinioned and argumentative Allie, and her sister, sit quietly and knit socks. No doubt Allie had a gleam in her eye while knitting socks for the Rebel army from yarn balls whose centers contained the family's gold watches, hidden successfully from Yankee eyes and greedy hands.

A Federal officer passed by and struck up a conversation with Allie—actually it was more like a war of wills. According to Allie, "He attempted to reconstruct me by arguments to prove the sin of secession and the certainty of our subjugations." This was a big mistake on his part, for Allie's "tongue was loosed" and her "heart was fired." She would rise to her feet as if some wave of inspiration had come to her that would change his opinions forever, only to have her sister beg her to sit down and collect herself. At length the officer said, "I see it is no use to argue with you." She added, "Nor I with you, for if you convince a man against his will he's of the same opinion still."

A Yankee band marched by playing "Dixie." Allie commented, "They must be at a loss of tunes for they're playing one of ours." The band then began to play "Yankee Doodle." That was too much for Allie, who took her sister by the hand and went inside, retorting, "We will not listen to THAT tune!"

High-spiritedness apparently ran throughout the household. Tabitha, a servant of the Travis family, saw Yankees breaking into her slave quarters and taking her prized things. One was a black soldier who was wearing her newest styled hat. She went up to him and shook her fists in his face, shouting, "Oh if I had the power like I've got the will, I'd tear you to pieces." It is not known if she intimidated him into giving her back the hat.

A New York paper wrote a story of the Covington women. "They were very pretty and intelligent, but great Rebels. While the

bands were playing 'Dixie' they were all smiles, but as soon as they commenced playing 'Yankee Doodle,' they went in, shut the doors, and closed the blinds."

That sort of notoriety must have pleased Miss Allie Travis of Covington, Georgia.

## DOLLY SUMNER LUNT BURGE OF COVINGTON

Dolly Sumner Lunt was not born a Southern belle. She was a native of Maine and related to the noted abolitionist Senator Charles Sumner of Massachusetts. He was the senator who was caned until senseless while sitting at his Congressional desk. An overheated South Carolina Representative, Preston S. Brooks, was the one who attacked Sumner. He resented Sumner's sneering references to his own uncle, Senator Andrew P. Butler of South Carolina, and he abhorred Sumner's stance on the issue of slavery in Kansas.

Dolly came south with her first husband, Dr. Samuel B. Lewis, and their baby daughter. Both husband and daughter died within a year, and the widowed Dolly began to teach school in Covington, Georgia. In 1850 she met and married the wealthy Thomas Burge and took charge of his enormous plantation, five children and one thousand slaves. Thomas died in 1858, before the Civil War began, leaving his wife to manage the large estate and holdings.

On November 16, 1864, Dolly knew the Federal troops under Sherman were headed her way—it was just a matter of time. She had her nine-year-old daughter, Sarah Cornelia (little Sadie), with her as they went to town for supplies before they braced themselves for the invasion. Inflation during the war caused coffee prices to soar to seven dollars a pound. She paid five dollars for ten cents' worth of flax thread and six dollars for sewing pins.

By November 17, there was still no sign of the Yankees. How slowly they were advancing, and how long could she bear the suspense of awaiting their arrival? By the eighteenth, she could see the fires on the horizon and knew she'd better start preparing for the inevitable onslaught.

She took a barrel of salt, which cost her $200 in the inflationary war market, to the slaves' gardens, put paper on top of it and covered it with leached ashes. Then she put a board on top of it,

to make it look like a leached tub, and daubed it with ashes. (There are similar hiding stories of tubs filled with molasses, also a highly valued item.) She hid meat from the smokehouse under fodder in the old house, hid the wagon and gear, told the servants to hide their things too (there were reports that the slave quarters were also commonly ransacked) and then told them to go back to their plowing. She took the fattening hogs to the Old Place Swamp for hiding. She packed clothes for herself and her daughter, thinking they'd soon be homeless. Then she waited.

That night she slept in her clothes. On November 19, all hell broke loose. In her own words:

> *Like demons they rush in! My yards are full. To my smoke-house, my dairy, pantry, kitchen, and cellar, like famished wolves they come, breaking locks and whatever is in their way. The thousand pounds of meat in my smokehouse is gone in a twinkling, my flour, my meat, my lard, butter, eggs, pickles of various kinds—both in vinegar and brine—wine, jars, jugs all gone. My eighteen fat turkeys, my hens, chickens, fowls, my young pigs are shot in the yard and hunted as if they were rebels themselves. I was utterly powerless…I saw driven first, old Dutch, my dear old buggy horse, who has carried my beloved husband so many miles, and who would so quietly wait at the block for him to mount and dismount and who at last drew him to his grave; then came Old May, my brood mare, who for years had been too old and stiff for work, with her three year old colt, and her last little baby colt. There they go! There go my mules, my sheep, and worse than all, my boys* [slaves]*!*

A Captain Webber from Illinois came to her house. He knew her brother Orrington Lunt of Chicago. Dolly burst into tears, imploring him to see her brother when he was back home in Chicago and tell him of her destitute state. Captain Webber assured her the dwelling house would be spared but probably not the outhouses. She would not be homeless or destitute. In parting with him, she felt she had just met an old friend.

By Sunday, the next day, the Yankee troops had passed, "leaving me poorer by $30,000 than I was yesterday morning and a much stronger Rebel…such a day if I live to the age of Methuselah, may God spare me from ever seeing again."

After the war Dolly married the Reverend William J. Parks, a Methodist minister, and moved to Oxford, Georgia. When Parks died in 1873, Dolly, now three times a widow, spent the rest of her life on the Burge plantation.

## MISCELLANEOUS HIDING STORIES: FINDERS KEEPERS, LOSERS WEEPERS

Yankee bummers and foragers got wiser and wiser as the march wore on as to "typical hiding places," forcing Georgia women to become more and more clever in their ruses. A number of those stories are included here.

ↂ

Four Georgia women sat on their front porch in Covington, rocking in their rockers as the march rolled by, wave after wave. They kept looking at a spot of freshly dug soil—usually a tip off to a hiding place for valuables. Yankee soldiers were quick to notice the spot and quick to pick up on the women's nervous glances. Immediately they began to dig up the suspicious plot. In this case, they unearthed a pine box, finding the remains of a dead dog, but no silver or jewels. They quickly reburied the coffin, disappointed in their findings, as the women cried out, "It looks like poor Curly will get no peace. That's the fourth time he's been dug up today."

ↂ

Otelia Atkinson was a teenager in Madison, Georgia, when Sherman's army passed. She was very artistic and had painted a picture of the Confederate flag. It was hanging in a prominent place in the family's parlor. When news of Sherman's approach came, the family knew this flag painting would not sit well with the Yankees, and they'd best hide it. But where? They removed it from the frame, rolled it up and placed it between two planks under a rug of an upstairs bedroom. They hammered the planks back in place and straightened out the rug.

# The March Begins

Madison was ordered not to be destroyed. Some say it was because the mayor was a personal friend of Sherman's. Some say it was because the women fried chickens for the Yankees. Some say it was because the town was too beautiful. Some say it was because the mayor was a Mason. Whatever the reason, the painting was never discovered and remains in the family to this day.

❧

Reverend Nathaniel Pratt of Roswell, Georgia, was one of the town's founding fathers, a friend of Barrington King. He eventually became Barrington's brother-in-law, marrying a sister named Catherine. Pratt was the minister of the Presbyterian church. All founding fathers and mothers in Roswell were Presbyterians. It was a requirement.

When the Yankees came to Georgia, Reverend Pratt stayed behind. His church was used as a hospital and his home, Great Oaks, across the street from the church, was used as the headquarters of General William Kenner Garrard. To prepare for the Union occupation, the Pratts wanted to hide their valuables. Their home featured a "good morning" staircase, which separated the house into sections. The pine boards leading to the eaves were loosened. Those on the south side of the house were labeled "Augusta" and those on the north side were labeled "Macon." Various items were hidden under the boards, which were slipped back into place. Family folklore says they had a christening service to bid farewell to their items hidden in "Augusta" as well as those hidden in "Macon." When the Yankees came, the Pratts, being a church family after all, could give a truthful response when asked where their valuables were: "sent to Macon," or "sent to Augusta."

There's also the story of the church's silver communion service and how it was successfully hidden. Reportedly, a poor mill woman took the service piece by piece to hide in her house. She felt assured that the Yankees would not bother searching for any valuables in her humble abode.

❧

In Liberty County, stories are told that when the Yankees came through, all small boys seem to have disappeared. Were there only daughters born to Liberty County parents? It turned out the

mothers were terrified by rumors that the Yankees, like the soldiers of the Pharaoh of ancient Egypt during the Passover, would kill their firstborn sons. So these Liberty County mothers disguised their young sons in girls' clothing. One distraught mother purportedly caught her "daughter" sliding down the banister in her dress and cried out, "Bessie, my son, you come down from there!"

ᙍᙍ

A bittersweet hiding story is told by the Rossee family from Putnam County, Georgia. Rebecca Parker Rossee, the mother of six children, was told her husband lay ill and wounded in the Kingston Hospital. She was to go to him at once, leaving her children behind in the care of Aunt Bessie, one of their house slaves. This was at the same time as Sherman's troops came through their area. When the Union soldiers arrived, they demanded the family's food. They caught the chickens and captured the cows and then demanded the key to the smokehouse. Aunt Bessie yelled, "No sir!" Then she swallowed the key—apparently a big one, too. It was to no avail, as the Yankees broke open the lock, taking everything except for a pillowcase half full of corn meal. Aunt Bessie ran after the Yankees, yelling for them to leave more behind, but it was of no use. The mother, Rebecca, returned home with a coffin. Her husband Lewis had died before she reached the hospital. He was buried somewhere on the home place.

## LOUISE CAROLINE REESE CORNWELL OF HILLSBORO

During the summer of 1864, Louise Caroline Reese Cornwell nursed wounded Northern soldiers, victims of General Stoneman's failed raid near Macon. In late July, Union Generals Stoneman and McCook undertook "big raids" to Macon, ultimately, they hoped, to free Union prisoners at Andersonville. They failed badly, ending with casualties and the humiliating capture of General Stoneman himself, who tearfully sent a telegram with the bad news to his wife. Stoneman's raid was an embarrassment to Sherman, who thought he'd surely lose his job over this fiasco. Most of the Union men Louise attended to were mortally

wounded, did not survive even with her attentive care and lay buried near her property.

With Louise in her Hillsboro home lived her elderly mother, a niece and two young lady cousins, refugees from Memphis. No men were close by to provide protection, probably a good thing given the advance of Sherman's army. Georgia women learned that abandoned houses were the ones most likely to be burned. Federal soldiers would show no mercy to Confederate men, who would more than likely be taken as prisoners of war or killed if they dared to show any resistance. It was different for the women, as long as they showed no resistance. Louise knew to stay on her front porch to show the Yankees that her house was occupied.

She was standing on her porch on November 19, 1864, when the procession of Federal troops started, lasting four long days. Yankee bummers drove off every living thing from her estate, burned the outlying houses and took or destroyed the grain. Her mother was old and frail and began to falter from the excitement. By nightfall of the first day, she could no longer rise from her chair. She never fully recovered.

The following day, General Oliver Otis (O.O.) Howard and his staff officers came for tea. General Howard was a former mathematics professor who had attended Bowdon College and then West Point. He was on the verge of becoming a minister when the war broke out. He was an avid abolitionist. Later in his life, the all-black college Howard University of Washington, D.C., was named in his honor. It was said that even in battle he was as much a moral crusader as a warrior and insisted that his troops attend prayer and temperance meetings.

While Louise fed General Howard and his staff the last of her food, the general sat and asked God's blessings, as was his habit. She thought, *The irony of it all!*—he asked for God's blessing while the sky was lit red from burning houses nearby, all done under his command. With all the Southern graciousness she could muster, she invited him to stay the night. He politely refused, saying it was best he be with his men, a rule he always followed. However, his staff officers stayed, played her piano and sang songs well into the night. There was a loud knock on the door. Soldiers asked if she feared them. She replied if they were gentlemen, then she did not. Then General Howard provided her with a guard, at least for that evening.

For four long days the infantry came through. It was sleeting, or at best a cold rain fell, and Louise had a hard time keeping the men out. One soldier came in and searched through her bureau drawers and wardrobe, taking some fine combs. But he refused the worthless Confederate scrip. She wondered if God had truly created man in his own image.

When General Blair's command came through, they played and sang variations of the song "Lorena" in her front parlor. This song was a particular favorite of the Confederacy and came to be singularly identified with the Southern cause. Hundreds of Southern girls were named Lorena, after the song's heroine, as well as at least one steamship. It was the most played song in the Confederacy. Louise thought the Yankees' version disrespectfully mocked her woe.

The following day the Federals ordered her to vacate her house. She stood her ground and said, "If you will burn our house, you can burn us in it. You have taken everything we possess; now burn us if you will, for we will not get out." She was testing what she'd been told—that abandoned houses were more likely to be burned than inhabited ones. She refused to abandon her house. The house was spared.

A Dr. Bondo of Missouri came by during the four days. He was told that Louise was safekeeping a likeness of a young lady, given to her by a Union soldier she had nursed. The soldier survived but was sent home disabled for life. He was asking for this photographic keepsake of his sweetheart. She no longer had it, having given it to Lieutenant Daniel Murphy to be returned to the disabled soldier. Dr. Bondo thanked her for her loving, tender treatment of their wounded men. She noted that at least there was one Yankee who had some feelings of humanity in his heart toward females.

## LORENA

*A hundred months have passed, Lorena,*
*Since last I held that hand in mine,*
*And felt the pulse beat fast, Lorena,*
*Though mine beat faster far than thine.*
*A hundred months, 'twas flowery May,*
*When up the hilly slope we climbed,*
*To watch the dying of the day,*
*And hear the distant church bells chime.*

# The March Begins

*We loved each other then, Lorena,*
*More than we ever dared to tell;*
*And what we might have been, Lorena,*
*Had but our lovings prospered well.*
*But then, 'tis past, the years are gone,*
*I'll not call up their shadowy forms;*
*I'll say to them, "Lost years, sleep on!*
*Sleep on! Nor heed life's pelting storms."*

*The story of that past, Lorena,*
*Alas! I care not to repeat,*
*The hopes that could not last, Lorena,*
*They lived, but only lived to cheat.*
*I would not cause e'en one regret*
*To rankle in your bosom now;*
*For "if we try, we may forget,"*
*Were words of thine long years ago.*

*Yes, these were words of thine, Lorena,*
*They burn within my memory yet;*
*They torched some tender chords, Lorena,*
*Which thrill and tremble with regret.*
*'Twas not thy woman's heart that spoke;*
*Thy heart was always true to me:*
*A duty, stern and pressing, broke*
*The tie which linked my soul with thee.*

*It matters little now, Lorena,*
*The past is in the eternal past;*
*Our heads will soon lie low, Lorena,*
*Life's tide is ebbing out so fast.*
*There is a future! O, thank God!*
*Of life this is so small a part!*
*'Tis dust to dust beneath the sod;*
*But there, up there, 'tis heart to heart.*

*Written in 1857, words by Henry DeLafayette Webster,*
*music by Joseph Philbrick Webster*

## To Save or Not to Save: Catholics and Masons

News quickly spread across the South that displaying any Masonic connections one might have would possibly spare the wrath of the Union soldiers. Perhaps because Sherman's father was a Mason, many Masonic homes in Georgia were spared the torch or even entry by greedy soldiers. The following women made the most of their husband's Masonic connections to protect their homes and families.

❧

Dr. J.W. Simpson was a Confederate doctor who, according to family legends, became ill during the war and was returned to his home in Fort Valley, Georgia, to recuperate under his wife's tender care. He was still at home when Yankee soldiers came through on their march to the sea.

There was a loud knock on the door and Dr. Simpson's wife, Sara, hurried to answer it. She saw her husband's Masonic pin on the table, quickly grabbed it and pinned it on her bodice. Frightened by the Yankee advance and fearing for her husband's safety, she gingerly opened the door. A Yankee captain, upon seeing her Masonic pin, tipped his hat as if to say, "You're safe, ma'am." He turned to his men and ordered them away from the house. They ravaged the smokehouse, burned it and the carriage house and then departed. Sara rushed to check on her husband, hidden away during the raid. He was safe and reportedly told his wife that except for her heroic act, he would have been captured and made a prisoner of war. In a bittersweet ending, he died shortly afterward from the results of exposure.

❧

A Mrs. Green of Sandersville tried, unsuccessfully, a different ploy—demanding protection because she was a Catholic. She had heard that General Sherman's wife was a Catholic. She was, but the general himself never converted (apparently a bone to pick in the Sherman family, with wife Ellen being so devout). Mrs. Green tried the tactic on Major Henry Hitchcock, Sherman's

adjutant, well known for his fairness during the march. He replied, "Madam, it's a pity the Catholics in the South haven't acted so as to protect themselves."

In spite of the killing of twelve Federal soldiers in Sandersville (probably by out-of-towners and scavengers, not townspeople), no houses were burned. Mrs. Green probably did not need to use the Catholic ploy after all.

<div align="center">ᏇᏇ</div>

According to folklore, Mary Williams was worried about Sherman and his men taking the family silver, so she placed it in a flour barrel and set her little daughter, also named Mary, on top of it. When the soldiers arrived and started to lift her up off the barrel, they looked up over the fireplace and saw little Mary's father's Mason sword and they left, without touching anything else.

<div align="center">ᏇᏇ</div>

Mrs. Nora Canning successfully used her Masonic connection to help her sick husband, who had nearly been hanged by some Yankee hooligans having their "fun" with him, trying to find out where his watch and gold were hidden. The Cannings fled from their Macon house, where they thought the Yankees were headed, to the safety of their Louisville, Georgia plantation. They made the wrong choice.

Yankees raided their plantation, searching through everything in the house, including bureau drawers and the clock. Nora said to one, "Sir, there is one place in the room you have not looked in to," and she pointed to a small box on the mantel. He turned away with a curse upon all Rebel women. Now he knew Mrs. Canning was no shrinking violet.

Nora watched helplessly as her husband was taken to the swamp. When he returned, he was nearly dead, his throat parched and swollen from the scare tactic "hangings." He told his wife to give the Yankees his gold watch. She still persisted in being tough, "Why, they have no business with your watch." He retorted, "Give it to them for I am almost dead." So she did. He took to his bed with a scorching fever. But the Yankees cut their well ropes and took the buckets, so she had no water to give her husband.

More soldiers came, tried to pull her husband from his bed and she begged, "Is there not one good Samaritan among you?" Then she used her husband's Masonic connections, appealing for a brother Mason to protect them. A New York soldier said his officer was one and gave instructions to "knock down the first man that dared to touch the couple." They were given a bucket, some water, coffee and sugar, and left alone after that.

## KATE HESTER ROBSON OF MADISON

Kate Hester grew up in Madison, Georgia, as a hopeless romantic and a scamp. In her own words, she was "continually falling in love," first engaged at fifteen, but not for the last time.

Kate was quite the trickster, too, and loved playing jokes at school. Once she caught some chickens, tied their legs together and put the tied chickens in a desk in the big chapel where the whole school studied. When roll was called, she made her chickens "squak" appropriately, or inappropriately, as she heard her name called out. Then she heard her name called out again and angrily: "MISS HESTER!" She was found out. And she knew the next day she'd be tempted to do, and would accomplish, something equally as outrageous.

She boarded with four different families while attending the Georgia Female College (perhaps because of her tricks?) and found her future husband at the house of family number four.

Si Robson was a store owner in Madison. He was an old bachelor, whom most young girls were afraid of. But not trickster Kate. She became engaged to him, even though he was twelve years her senior, and vowed to change her ways. She became an angel at school and graduated at the age of 16½. She married on November 1, 1855, living in Madison until moving to Atlanta in 1859. Her husband was literally the head of the family, which turned out to be a rather large extended one, with many heads living under the same roof. They lived on the corner of Marietta and Spring Streets where Si had his grocery store, S.B. Robson and Co.

And then the war came and brought out Kate's Southern fervor. She took to sewing—first a Confederate flag, presenting one to the Raccoon Roughs, General John B. Gordon's first company from the

North Georgia mountains. Then she sewed soldiers' uniforms, taking her machine to city hall, which became an assembly line factory for uniforms.

Never losing her trickster spirit, she once nursed a wounded Yankee who had one eye shot out. Without blinking an eye herself, she told him if he ever got well and continued to fight against the South, she hoped his other eye would get shot out.

When the war closed in on them, the Robsons moved to their Albany plantation house. Her husband had been appointed State Commissary and Salt Agent, his agency helping to provide supplies for the soldiers.

Kate wrote of the demoralization of the South, "It will never be equaled until Gabriel blows his horn." But at least the Yankees hadn't captured Santa Claus, as she put it, for they managed to have a Christmas in 1864 even though Confederate money had gone to the "bow wows." The first greenback she ever saw was when she sold some homemade lye soap to a Yankee soldier who had come to Albany. She said, with a twinkle in her eye, he had come to Albany "to clean up."

> ### Sherman's Letters Home: Dear Minnie
>
> Sherman's first child, Maria Theresa Ewing, was nicknamed Minnie. She alternately called her father "The Man," "Papa" and then "Tump." He wrote her often during the war. A sample follows:
>
> *Memphis, TN, Aug. 6, 1862*
> *Dearest Minnie:*
>
> *Pray for the end. But pray too that it may end before our people become robbers and murderers...Hundreds of children are being taught to hate my name, but that is war...Your mama and grandpa think it is a great thing to be a high general. I would in any war but this, but I cannot look on these people but as my old friends, and every day I meet old friends who would shoot me dead if I went outside camp, and who look on me as a brutal wretch...*
>
> *Your Absent Papa,*
> *W.T. Sherman*

## EMMA HIGH OF MADISON

Madison, Georgia, was described in antebellum days as the "wealthiest and most aristocratic village on the stagecoach route

between Charleston and New Orleans." Rich planters composed most of the town's population. Today there is still evidence of the town's sleepy, historic beauty.

On November 17 and 18, 1864, however, there was not a rich planter to be seen. Sherman and his army were coming, and all the white men fled or were in hiding.

General Henry Slocum and his four thousand men were encamped in front of the High home, where Emma, her mother and the cook watched cautiously from their porch. Mrs. High waved high her husband's Masonic apron and said, "I am a Mason's daughter, and a Mason's wife, and I ask you give me protection." She had heard that Federal soldiers, under direction from Sherman himself, were to respect and leave unharmed the houses of Masons. General Slocum assured her he would and said, "Put out your light and go to sleep and you will not be disturbed."

They were not. Until the next morning, that is, when aromas of freshly baked gingerbread wafted from the kitchen. The High family cook was famous for her gingerbread cookies. To hungry, far-from-home soldiers, it probably little mattered if they were burnt or baked without sugar, as long as they were homemade. They rushed in for the cakes, dropping a coin in the tin pan the cookies were baked in as they left with their treats. The cook was so excited, never dreaming that she could make money off her gingerbread. (This is not the only story of Georgia women who used their cooking skills to soften a Yankee's vengeful heart.) Her excitement was squelched when one soldier, who grabbed the last cookie, also grabbed the tin pan with the coins in it. She ran after him, crying, "Our boys wouldn't have done that, for they has had some raisin' and has got manners too!" It is not known whether or not she shamed him into returning the coins.

Emma watched the town calaboose (jail), the train depot and the commissary burn, even though they had been promised the town would be spared. At least the beautiful houses were untouched. But the gardens were stripped of the beautiful fall blooms—roses and camellias. She watched curiously as soldiers wove the flowers into garlands, decorating their arms and heads and waists, making great sport of it.

# The March Begins

## MORE HIDING STORIES: THE WAY TO A YANKEE'S HEART IS NOT THROUGH TURNIP GREENS

The Spences lived in Rockmart, Georgia. They knew the Yankees were advancing, having heard from their neighbors how their houses, including feather beds and pillows, were literally torn up. Neighbors managed to save their gold by throwing it in the turnip patch, which the Yankees avoided like the plague. Perhaps this ruse would work for the Spences too.

The mother of the family put a bag of gold in the bottom of a dish pan and covered it with turnips she gathered from the field. The Yankees came into her kitchen, the turnips were again ignored and her gold was safe. Apparently turnips and turnip greens were not Yankee delicacies.

Another family story says the gold was wrapped up in the baby's diaper. They made sure it was good and soiled so the Yankees would not touch it. This ploy worked too.

❦

Amanda Katherine Houston lived on Clairmont Street in Decatur when the Yankees came. Her husband, Major "Wash" Washington Jackson Houston, served in the Confederate army and was stationed near Atlanta. Even though the Yankees occupied Atlanta, Wash would try to sneak home whenever he could to check on his wife and children.

One day he was in a rush to get home to see his gravely ill daughter and stopped to rest at the Avary farm. They spotted Yankees coming toward the house. Mrs. Avary told him to "run hide in the collard patch. There never has been a Yankee who would get near collards." Sure enough he was safe, but he was later captured near the cemetery in Decatur and held on suspicion of being a spy. He was about to be shot when he gave the Masonic distress signal. He went on to tell the story of his sick child and his need to get home as quickly as possible. The Yankee captain believed his story and even escorted him home. He never suspected that Wash was a major in the CSA. Instead, he thought Wash was a merchant allowed to stay in Atlanta during the occupation.

❧

Sue Sample from Newberry, South Carolina, was visiting her sister-in-law Rachel, who lived in Millen, Georgia, when the Yankees came to call. Rachel put cream on the counter that she had set out to "turn." A hungry, desperate Yankee soldier rushed into the kitchen, hurriedly drank the soured cream and began to gag. He screamed they were trying to poison him. The two women probably thought, "If only!" for when General Giles A Smith found out that Sue was from South Carolina, he told his soldiers to go out of their way to annoy her. He informed her that they would next be heading to her Palmetto State, where no house would be left standing. After they finally left, Sue made the comment, "I do not think any race of people can swear so much as the Yankees." The two women scavenged whatever food they could find that was left behind at the enemy bivouac. They lived on parched corn, saying, "Persons were obliged to pick what they [the Yankees] left or perish."

## PLACES SHERMAN DID NOT DESTROY AND THE FOLKLORE SURROUNDING THEM

Despite Sherman's ruthless destruction and desire to bring the South completely to her knees, some parts of Georgia were inexplicably saved. The stories surrounding these places have been passed on from generation to generation, and have likely been embellished or enhanced as suited the teller of the tale. Don't look for too much truth here.

Several stories exist on why the town of Madison was saved. Some say it was because Sherman had a girlfriend who lived there. Others say it was spared simply because of the beauty of the town and its women. Still another story tells of Joshua Hill, mayor of Madison, who was a friend of Sherman's. He was actually a Union sympathizer, a former U.S. senator and close friend of John Sherman, General Sherman's brother, who was also a U.S. senator. It is known that Sherman allowed Joshua to go to Cassville to retrieve his soldier son's body. But rumor has it that

# The March Begins

Sherman was fond of Hill's daughter, and when Hill "gave" his daughter to Sherman, he spared the town. Then there is the belief that Madison was spared simply because the women made fried chicken dinners for the Federal soldiers.

Augusta supposedly wasn't burned because an old girlfriend of Sherman's was buried there, and Newnan is said to have been saved because Sherman's sister lived there. According to some, Stilesboro was spared because Sherman saw an inscription in the schoolhouse reading "For God and country." A Jenkinsville church was spared because "God civilized the devil Sherman" and made the Yankees feel guilty. Monticello was spared because the town made a meal for the enemy. When you break bread together, it's a gesture of warmth, trust and hospitality to be honored.

Several stories surround the preservation of Savannah. Perhaps it was spared because the madams of the town sent ladies to entertain Sherman's troops. Or it is also said that Savannah was saved to be a birthday present for Ellen Sherman, wife of the general. It is known that Sherman was called the Military Santa Claus for capturing Savannah and presenting it to Abraham Lincoln as a Christmas present.

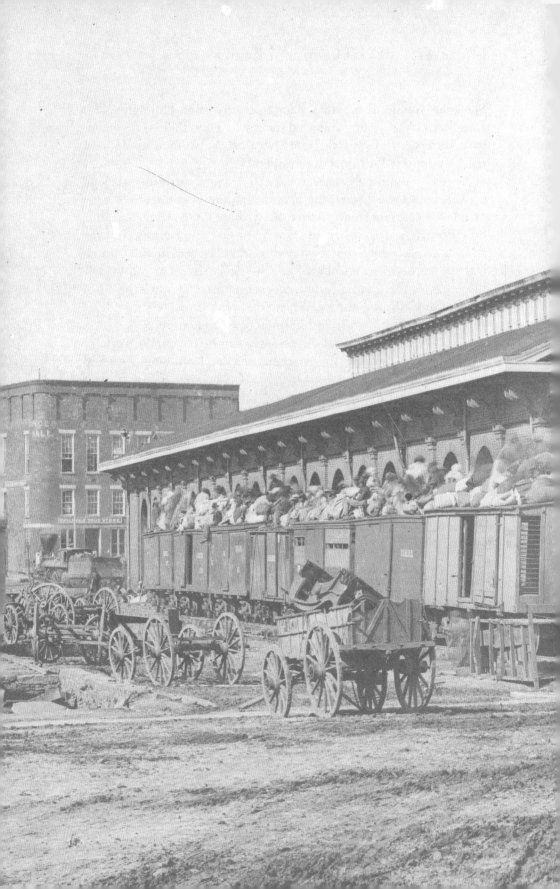

*Chapter 3*

# Advance to Georgia's Capital

Milledgeville was Georgia's capital during the Civil War. As the Yankees approached, the state legislators hurriedly finished business and fled. Governor Joseph Brown, in a vain attempt to defend the city, enlisted the aid of the young cadets from the burned Georgia Military Institute in Marietta, who were now stationed in Milledgeville. These were mostly boys who had never seen action. The governor also made a deal with prisoners. If they stayed to defend the city, he'd pardon them. But only around one hundred of them agreed to this folly. These makeshift soldiers had no real weapons, only some medieval pikes the governor had ordered made for them.

In one final plea, the governor asked the citizens of Georgia, "Remove your Negroes, horses, and provisions from Sherman's army and burn bridges and block up the roads in his route. Assail the invader in front, flank, and rear by night and by day. Let him have no rest." The people were doing none of these things. Confidence in Jefferson Davis and the Confederate government was failing. Where was the support to Georgia? How could the citizens meet sixty thousand Federal soldiers without the help of the Confederate army? This was truly a "rich man's war and a poor

man's fight." Realizing the futility of it all, Governor Brown fled and the "soldiers" were sent to Macon.

When the Yankees arrived in Milledgeville on November 24 and occupied the Georgia State House, it was said they had great fun engaging in mock legislature sessions, especially in reenacting the famous Georgia secession session. Their antics provided some comic relief for General Sherman, who was headquartered in the governor's mansion. The city was not torched, nor could Sherman and gang remain long, for his objective was to get to Savannah as soon as possible. And he was not going by way of Augusta—that had been decided. The troops were on the march again by November 26.

Included here are two accounts from women who lived in Milledgeville, two accounts of women who lived nearby, a story about Sherman's alleged first love from Augusta and a vitriolic letter to Mrs. Sherman.

## ANNA MARIA GREEN:
## JOURNAL OF A MILLEDGEVILLE GIRL

Anna Maria Green was twenty when the Yankees came to Milledgeville. She was a graduate, at eighteen, of the women's college in Covington. After graduation, she began her true occupation—searching for a husband. She kept a diary, which she faithfully wrote in from January 1, 1861, until her marriage after the war. Her published diary (one-third deemed too trivial by her editors to be published) serves as a descriptive account of the departure of the state legislators and the arrival of the Yankees.

Anna was the second youngest (of eight) of Dr. Thomas Green, superintendent of the Georgia State Asylum for the Insane since the 1840s. She grew up in the asylum, her family living in the main dormitory, eating their meals with the staff and patients. Her father served as superintendent for thirty-three years, instituting many reforms, including the family model, treating the patients as an extended family.

Anna had a rather tragic early life, as her mother died in 1860. Her father then married his sister-in-law. Anna's oldest sister died that same year, as well as another married sister. No wonder she was absorbed in "air castle building," as she called her romantic yearnings for the perfect husband.

# Advance to Georgia's Capital

Sections of her diary are quite eloquent, as her report of May 6, 1863, shows:

> *It is when the casualties of a battle reach us that the heart turns faint and sick to see the long list of killed and wounded with here and there a familiar name, but then how thankful that a loved one's name is not on that dreadful list, then the tears fall in silent gratitude.*

But it is her anxious anticipation of the arrival of the Federal army, with sightings of nearby burnings during the summer and fall of 1864, that best serves the purposes of this book. As the enemy advanced into Georgia, she wrote, "They have spread dread and consternation." Would they reach Milledgeville? And when? In her own words, "I trust they may not invade our home with their polluted tread."

It was only a matter of time until the Yankees reached Milledgeville, the state capital. On November 19, 1864, Governor Brown ordered the evacuation of Milledgeville. Anna wrote:

> *The scene at the State House was truly ridiculous…the members were badly scared, such a body of representatives made my cheeks glow with shame…They could not stand for the defense of their own capital.*

Her father and the rest of the extended family still living at the asylum remained behind, out of duty to the patients and assurance that the Yankees would not harm a doctor or a hospital. Anna watched as four wagonloads of books from the state library came to the asylum for safekeeping. (In fact what Anna saw on the wagons were not books from the library but were actually part of the state's valuable archives, and probably less replaceable than the books. The library was plundered by the Yankees, and most of the books were thrown out onto the muddy grown, trampled on, destroyed or stolen.) She helped her father bury barrels of syrup (it is interesting what was deemed important during wartime) and conceal the family silver beneath the reservoir on the Avenue. She made a purse, which she wore on her own person, to conceal her jewelry. (It is obvious they trusted the Yankees would not violate the women.)

When the Federals came, Sherman occupied the executive mansion, the former home, until a few days prior, of Governor and Mrs. Joseph Brown. The Federal soldiers met with no resistance. Cadets from the Georgia Military Institute and some 150 freed prisoners, who promised to help defend the city in exchange for their release, had been sent on to Macon; Milledgeville had been given up. The Federals looked on in confused awe at the city arsenal containing ten thousand pikes the governor had ordered made to defend the city. How could these possibly hold up against their new repeating rifles? What sort of medieval war were the Georgians hoping to fight? And with young boys and prisoners?

The Greens were given a guard at the asylum to assure them it would not be burned or ransacked. All that they personally lost during the four-day siege of Thanksgiving 1864 were two mules. But the loss was much greater to Anna's spirit. In her own words:

> We were despondent. Our heads bowed and our hearts crushed—the Yankees in possession of Milledgeville. The yankee [sic] flag waved from the Capitol—our degradation was bitter, but we knew it could not be long, and we never desponded, our trust was still strong. No, we went through the house singing, "We live and die with Davis." How can they hope to subjugate the South? The people are firmer than ever.

Her spirit lifted when the Yankees left and Wheeler's cavalry entered. "How our hearts leaped for joy, and as a few ragged men came riding up and bowed and brandished their pistols, the tears streamed from our eyes."

But of course, this was short-lived. In April of 1865 she wrote, "When General Lee surrendered, we bitterly mourned it." However, she had marriage proposals to deal with—one from her oldest sister's widower, Adlai Houston. Her father disapproved, saying he was too old for Anna. Adlai died shortly thereafter. Perhaps she could have been a well-off widow, if her father had agreed to this proposal. Within six months Anna was engaged to her future husband, Samuel Austin Cook, two years her junior. He was a patient at the asylum and was being treated for alcoholism. Apparently he was cured, or at least cured enough to sire ten children. Tragically, Anna saw four of them die in infancy, two in their teens, with only three outliving her.

She was the last survivor of the eight Green children, dying at the age of ninety-two in 1936. She wrote *The History of Baldwin County*, which is still in print today.

## Mary Ann Cooper Barnett: Georgia's Dolley Madison

Mary Ann Cooper Barnett was the wife of Colonel Nathan Crawford Barnett, Georgia's Secretary of State when Sherman came to Milledgeville. She was her husband's second wife; his first wife, Margaret Cooper, passed away early in their marriage. Mary Ann was the daughter of Dr. David Cooper, who fought in the War of 1812, and was the first superintendent and resident physician of the State Asylum for the Insane. (Anna Maria Green's father was to follow.) Her husband, Colonel Barnett, was the nephew of William T. Crawford, the illustrious Georgian, who might have been our sixth president were it not for a paralytic stroke. The two obviously had strong political backgrounds and connections.

Mary Ann was described by her grandson Stewart Barnett as a "wee little thing barely five feet tall, never weighing more than 95 pounds in her life." She apparently was the woman behind her man, urging him on shortly after their marriage to a very lengthy career as Georgia's Secretary of State, which began in 1843 and ended in 1890. Georgia's Secretary of State, along with other duties, is charged with being the official custodian of the great seal of Georgia, which is attached to official papers by executive order of the governor.

When the Yankees were fast approaching Georgia's capital on November 18, 1864, Nathan reportedly outstayed all the state officials, guarding the state seal. He waited in his office until the Federals crossed the Capitol Square, then took the great seal and newly passed legislation and hid them both below a river bluff, waiting until dark for further action.

What happened next is told in several versions. At midnight, with Mary Ann's help, and probably their youngest son's help too, they buried the seal under a brick pillar of their house. Some say Nathan looked away while Mary Ann did this, so he could

truthfully say he didn't know where it was. Then Mary Ann took the new acts of government, not yet signed by Governor Joseph Brown (who had fled much earlier), wrapped them in oilcloth and buried them in the pigsty. She was known to say, "I had four fine porkers in the pen and I thought that the heat of their bodies would help to keep the papers safe."

Her husband escaped shortly afterward, leaving Mary Ann to face the invading Yankees. She'd heard of Sherman's reverence for the Masonic order and hung her grandfather's lodge apron on the gate. As a result, the house was never touched. There's a story told that the Yankees came later on looking for food at the Barnett house. Mary Ann told them she'd feed them, but the food would be poisonous. They never took her up on her offer.

When the Yankees left Milledgeville, Nathan returned and unearthed the seal and papers and returned them to their proper places. However, at the end of the Civil War, during the carpetbag period, he and Mary Ann hid the great seal again. He said he did it so the seal "would never be affixed to any of the documents of misrule that followed." Some say it was with this second hiding (rather than when the Yankees were coming) that he turned away so that, technically, he could say he didn't see where it was hidden.

In 1939 the Robert E. Lee Chapter of the United Daughters of the Confederacy at Milledgeville placed a granite marker honoring the Barnetts and their efforts to protect the great seal of Georgia. It reads:

> *The Great Seal of the State of Georgia and the Acts of Legislature, 1864. Four hundred and seventy feet east of this marker stood the home of Georgia's Secretary of State, Nathan C. Barnett, and his wife, Mary A. Barnett. On November 18, 1864, before the arrival of General Sherman and his army, the Georgia legislature adjourned and Nathan Barnett took with him the Great Seal and the Unfinished Acts.*
>
> *At midnight Mr. and Mrs. Barnett with their youngest son, buried the Great Seal under their house. Mrs. Barnett hid the Acts in the pigpen. When the legislature met in Macon, February 15, 1865–March 11, 1865, the Great Seal and the Acts were returned to the State. Neither had been captured by the enemy.*

## Mrs. L.F.J.: A Child Wife of Sandersville

She fell in love with a soldier boy who had been her pen pal and in March of 1863, when she was just fourteen, she married him. She's known simply in her own accounts as Mrs. L.F.J., a war widow at sixteen, left behind with a baby. She was a child wife, who went to live with her mother-in-law in Sandersville, Georgia.

Just one month after she was widowed, Sherman's army marched through Sandersville. The general was in a rage because twelve Federal soldiers had apparently gotten cocky and careless and ended up dead in Sandersville. They were hurriedly buried to try to hide the evidence. As it was, they weren't killed by citizens of the town but by stragglers. It didn't matter to Sherman who had killed them—the town needed to be punished.

The Confederate cavalry under General Wheeler was skirmishing in the area with some of the front running Yankee troops. Mrs. L.F.J. wrote of her account in the article "Child Wife of 1863," published in *Our Women in the War*, "Already the bullets rattled like hailstones against the house." Some Rebel soldiers came to the house of Mrs. L.F.J. and her mother-in-law and told them to retreat to the cellar. "For God's sake, ladies, go into your cellar. Don't you know those bullets will kill you?" But they had no cellar to go to, so they went to the back room and stood in front of the middle chimney, as the soldiers told them to do as the next best choice. Then the soldiers waved their caps and said, "We'll have to run. We can't fight the whole of Sherman's army."

The women asked what they were to do and were given the following advice, "Lock your doors. Keep inside. If the Yankees come, unlock the door, stand in the doorway, be polite, and ask for a guard. You will not be mistreated, I hope. God bless you ladies." And they were off.

Mrs. L.F.J.'s young husband and father-in-law had both been Masons, with the father-in-law being a prominent one. When the Federal troops entered Sandersville, some of the bummers rifled the Masonic jewels from the local lodge. Some blue-coated soldiers who were Masons watched in horror. They could not prevent the act, but they managed to procure the jewels and brought them to Mrs. L.F.J. for safekeeping. "Take these and put them safely back when the army pulls out." She hid them in a

ripped up feather bed and returned them to their proper place when it was safe.

Her baby was crying. She had no more milk to give him. A Federal soldier took pity on her and came back that night to share his rations. He brought some flour, ground coffee and green coffee beans. The cook grabbed the supplies and within an hour served hot biscuits and coffee. They sat together at the table—a boy of blue supping with a widow of gray. *Faith, hope and charity*, she thought. And of these three, *the greatest is charity.*

## EMMA MANLEY OF SPAULDING COUNTY MEETS COLONEL GEORGE E. SPENCER OF THE 1ST ALABAMA CAVALRY, USA

Emma Manley was the daughter of J.P. Stanley and was living in Spaulding County, to the south of Atlanta, when Sherman's army began the march. Her parents, worried about her safety and that of a great-niece facing the advancing Yankee army—the finest and freshest the North had to offer—sent the young ladies packing and off to Macon. Emma's brother, Manson, a nephew and other male family friends were stationed there in the Confederate army.

On November 16, 1864, she packed two large wagons with "edibles, valuables, and comforts" for her trip, stopping for an overnight at her sister's plantation, Sylvan Grove, in Butts County. Her brother and a few other Confederate scouts, sent to spy on the advancing Sherman's army, met her there. The next morning appeared to offer a "safe window" in which to continue their journey. Her brother and the other scouts accompanied Emma, the niece, a servant and a crippled former soldier named Ben Drake, who was their driver.

They stopped to take water from a well at Stephen Johnson's house in Jasper County but weren't allowed in for fear the Yankees would burn down the house for harboring refugees and Confederate soldiers. Brother Manson and fellow scouts took off when they saw Yankees approaching, leaving Emma in front of the Johnson house. When the Yankees pulled up beside Emma's wagons they asked her, "Where are those damn Rebels who were with you?" "Gone," was the reply. Emma's servant pointed the way, leading the Yankees down the wrong fork.

Of course this made the Yankees angry when they discovered the ruse that had made them look like fools. They made their way back to find Emma and her party and confronted them. Emma asked if there was a gentleman anywhere around to protect her. Colonel George Spencer of the 1st Alabama Cavalry, USA, answered, "Yes, I have a mother and sister at home and I'll protect you with my life."

Colonel George E. Spencer, although born in New York, led the 1st Alabama Cavalry, a regiment of what Sherman called "loyal Southerners," meaning Southerners who chose to fight for the Union flag. Every one of the eleven states in the Confederacy had regiments who stayed loyal to the Union. The 1st Alabama, or "Alabama Yankees," was without a commander until Colonel Spencer asked for the command. Prior to this commission, he'd served as chief of staff to Brigadier General Grenville M. Dodge. General Sherman felt so confident in the 1st Alabama, calling them his best scouts, that he made them his official escorts on the march. As members of the cavalry, they filled the traditional role of scouting, raiding, reconnaissance and flanking the enemy. They were doing their jobs, in advance of Sherman's large corps, as they encountered Miss Emma Manley and her niece.

The women watched as their "edibles, valuables, and comforts" and wagons and horses were confiscated. After the thieving soldiers left, they followed them, walking a mile to a two-room house where they found their emptied wagons. Federal soldiers were breaking open their trunks and distributing their possessions to local factory workers. A little girl had on Emma's new soft kid boots. Colonel Spencer rescued them for her, as she had on a pair of soft slippers, not fit for walking in. Her clothes were now torn from walking in the woods. The colonel forced the lady of the two-room house to take in Emma and company, as it was cold. Emma's niece said the colonel was obviously "smitten" with Emma, as he shouted to the house owner, "Take them in or I'll burn down your house damn quick!"

For the next few days he brought them three nice meals a day (hopefully not forgetting the house owner and her children) and provided forty men to guard the house. Some of the soldiers were still having fun with the contents of Emma's trunks. They found fifteen yards of silk fabric, no doubt intended to make

Sherman's Letters Home:
My Dearest Ellen

*[Vicksburg, 1863 (?)]*
*Dearest Ellen:*

*I have lived so much in Louisiana and Carolina, that in every battle I feel I must be fighting some of the very families in whose houses I used to spend happy days. Of course I know I must fight, but whenever the result can be accomplished without a battle, I prefer it.*

*Affectionately yours,*
*W.T. Sherman*

several fashionable dresses with, and draped the expensive fabric around their horses, decorating them as if part of a festive parade. They took the niece's lovely crepe shawl and put that on a horse, as Emma watched it all. "There we sat until Sherman's entire army passed; resting our heads in each other's laps."

Colonel Spencer lingered with the ladies until three hours after the army passed, reluctantly parting and leaving them with food and a fine horse. Emma gave the food and horse to the lady of the two-room house as thanks for taking them in. She and her niece returned to her sister's house in an old oxcart. It was a cold and bitter November day. They arrived at her sister's to see only the main house left standing, and all the outer buildings destroyed. They found her sister and servants all huddled in the master bedroom, the rest of the house a shambles. It looked as if it had been snowing inside the house. Feather beds and pillows had been torn up by General Francis P. Blair's men for their own amusement, to "see the feathers fly."

Emma, her niece, sister and brother Manson all survived their ordeals. After the war, Emma received several letters from Colonel (now Brigadier General) Spencer, who settled in Decatur, Alabama, where he became the only Republican senator from the state in quite some time. He had indeed been smitten by Emma Manley, but not as much as by May Nunez, a well-known actress very much his junior, who was the niece of Major General William W. Loring, CSA. It was May Nunez who became the second Mrs. Spencer.

# Advance to Georgia's Capital

## CECELIA STOVALL STELMAN OF AUGUSTA: SHERMAN'S GIRLFRIEND?

What's truth and what's fiction regarding the stories written about the beautiful Cecelia Stovall of Augusta, Georgia, purportedly the first love of General William Tecumseh Sherman? Did he spare her hometown of Augusta from the torch, as well as her palatial Bartow County home (where she was by then Mrs. Charles Stelman), because of his undying love for her? The story seems like a juicy romance novel, and in fact was the inspiration for Diane Haeger's 2004 novel, *My Dearest Cecelia: A Novel of the Southern Belle Who Stole General Sherman's Heart*. But what do we know for sure?

Cecelia Stovall (referred to as Julia Stovall in Edward J. Cashin's book *General Sherman's Girlfriend and More Stories about Augusta*) was an Augusta beauty, born into a Southern plantation world, right out of *Gone with the Wind*. Her brother Marcellus attended West Point Academy at the same time as William Sherman, although Sherman was several years his senior. Some say Cecelia met Cadet Sherman while visiting her brother and the two immediately fell in love. According to Stovall family history, she said to Sherman, "Your eyes are so cold and cruel. How you would crush an enemy. I pity the man who ever becomes your foe." Such foreshadowing befits a Greek tragedy. He answered, "I will ever shield and protect you."

If they ever considered marriage, Sherman, being the foster son of Senator Thomas Ewing from Ohio, and still continuing to support his widowed mother, would have hardly been considered worthy of becoming the future husband of the likes of Cecelia Stovall.

It is said their paths met again in Augusta, where Sherman was stationed at the U.S. Arsenal after graduation from West Point in 1840. But other stories say Cecelia fell for another West Point Cadet named Richard Garnett, who also happened to be stationed at the arsenal. This was again a match her father did not approve of. In reality, Cecelia had met and fallen in love with the handsome and appropriately wealthy Charles Stelman of Cass (now Bartow) County. She was whisked away to live in Rome, Georgia, in a beautiful white-columned plantation home overlooking the Etowah River, where she reigned as a queen until her dying days.

Sherman eventually married Ellen Ewing, the daughter of his foster father, in May of 1850. After his marriage he and Ellen immediately began producing offspring. It seemed a happy match.

But Cecelia's and William's paths were to almost cross again, this time many years later during the Civil War. In the spring of 1864 Sherman's army was in north Georgia. He had not begun the fateful march, but he was already using the torch. When his army approached the Stelman home, Sherman met a servant who said Mistress Cecelia had fled, in fear of the advancing Yankees. Sherman reportedly stuttered something like "N-n-not Cecelia Stovall, of Augusta?" Indeed, one and the same, only now she was Cecelia Stovall *Stelman*.

The servant pleaded with Sherman to spare the home. He did, and to bring the love story full circle, penned this note to Cecelia:

> *My dear Madam:*
>
> *You once said that you pitied the man who ever became my foe. My answer was that I would ever shield and protect you. That I have done. Forgive all else; I am but a soldier.*
>
> *W.T. Sherman*

Supposedly this note still remains in the Stovall/Stelman family collection.

As to the sparing of Augusta because Cecelia begged him to spare her hometown—it is widely believed that Sherman avoided Augusta because of the strength of Southern defenders he believed to be in Augusta, defending the vast arsenal there, and also because of his haste to reach Savannah relatively unscathed.

One final note—according to another legend, Union General Joseph Hooker, a classmate of Sherman's at West Point, had apparently also been taken with the lovely Cecelia Stovall.

## MRS. GERTRUDE CLANTON THOMAS OF BURKE COUNTY

Burke County sat directly in the path of Sherman's march, as the troops were fast closing in on Savannah. Mrs. Gertrude Thomas had a farm in that county, and her farm was ripe for a Yankee invasion.

She was one of those rare women in Georgia in the 1800s who was a college graduate; she was widely read, intelligent, an opponent of slavery and as outspoken as they come.

In her diary she wrote of General Sherman's appeal to women. "I don't know why…but that man Sherman has interested me very much—perhaps it is…that all women admire successful courage and…a very brave man. Our enemy, though he is, I can imagine that his wife loves him."

Her romantic notions of Sherman were quickly crushed when his bummers ransacked her farm. Anger brought out her catty nature and she penned a letter to none other than Mrs. William T. Sherman (Ellen) herself.

> *To Mrs. General Sherman:*
>
> [It's] *a few days since I read your husband's farewell telegram to you* [it had been published in the newspapers] *dated* [from] *Atlanta. Will you believe it? For a moment I felt sorry for you…so my heart went out in womanly sympathy for you.*
>
> *Last week your husband's army found me in possession of wealth, tonight our plantations are a scene of ruin and desolation…You bade him Godspeed on his fiendish errand… You thought it a gallant deed to come amongst us where by his own confession he expected to find only "the shadow of an army." A brave act to frighten women and children! Desolate homes, violate the sanctity of firesides and cause the "widow and orphan to curse the name Sherman for the cause" and this you did for what?*
>
> *You did this to elevate the Negro race. Be satisfied Madame your wish had been accomplished. Enquire of General Sherman when next you see him who had been elevated to fill your place.*

Gertrude was alluding to unsubstantiated rumors that Sherman had taken on a mulatto girl as his mistress. E.L. Doctorow toys with this idea in his novel *The March*. It is unclear whether Gertrude ever mailed this letter and, if she did, what Ellen Sherman's take on it would have been. Although the Shermans had a long and troubled marriage, there is no evidence of any dalliances until long after the war when he and Ellen were living apart. They never

divorced. Sherman remained devoted to her until her death and was unquestionably devoted to his children.

Perhaps it was enough for Gertrude to merely pen this letter—to vent her anger and the feelings of violation for what the Federals did to her property. Perhaps this was the only means she had to retaliate for the harm done to her.

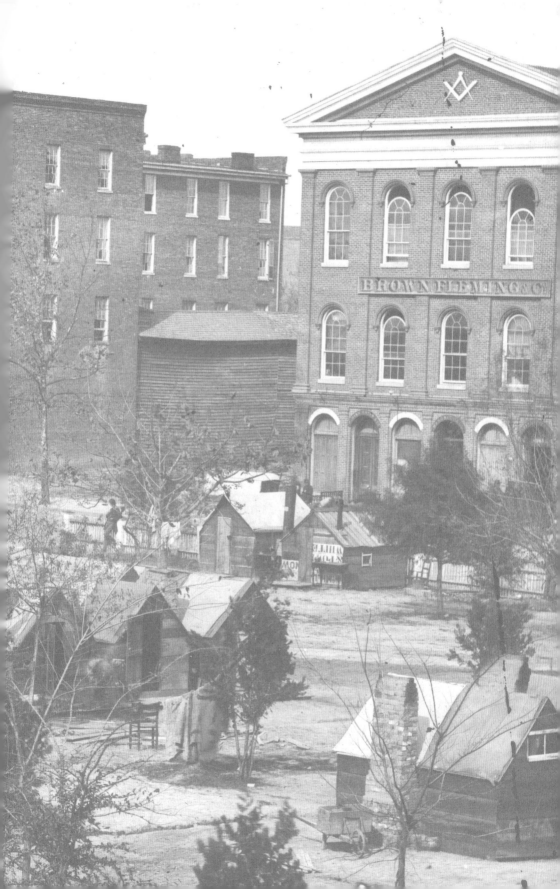

# Approaching Savannah

By December 12, Sherman's army was now on the outskirts of Savannah, but had to approach carefully until word was secured about the location of General Hardee's troops. So far, Sherman's troops had faced only minor skirmishes at Griswoldville and Sandersville. The only continuing trouble they had was from General Joseph T. Wheeler's Confederate cavalry, who behaved more like aggravating pests, having too small a force to inflict much damage. But General Hardee had an army of at least ten thousand, more if Bragg's troops arrived from Augusta. Sherman wanted to avoid a battle if at all possible, even if it meant allowing the Southern troops to escape.

Sherman's men had been on the march for over a month and were hungry again. Coastal Georgia with its swamps and sandy soil did not provide the masses of food middle Georgia had. The men were hardened on the march and had become experts at foraging and discovering hiding places. More than likely some of the worst acts of plundering occurred on the outlying areas of Savannah from December 12 through 19. Some of this was done by stragglers, who were the most vicious. Mischief was done by the cavalries on both sides.

Sherman's Letters Home:
My Dearest Ellen

*Dearest Ellen:*

*It seemed to me that the terrible energy they had displayed so early in the war was beginning to yield to the slower but more certain industry and discipline of our Northern men. It was to me manifest that the soldiers and people of the South entertained an undue fear of our Western men and like children, they had invented such ghost like stories of our prowess in Georgia, that they were scared by their own inventions. Still this was a power and I intended to utilize it…*

*Yrs ever,*
*W.T. Sherman*

Included here are several accounts of these coastal Georgia vicious attacks, with some humorous overtones. Also included is a story of the Nancy Harts, the best example of a women's home guard in Georgia, as well as some miscellaneous stories about vicious women.

## MARY SHARPE COLCOCK JONES AND MARY SHARPE JONES MALLARD OF MIDWAY

Mary Colcock Jones, the family matriarch, managed the family's thirty-five hundred acres of land, three plantations and multitudes of slaves after the death of her husband Charles in 1863. Charles was a nationally known Presbyterian minister, whose passion was to find a way to reconcile Christianity with the institution of slavery and provide religious instruction for enslaved African Americans.

The Jones family was quite prominent in Liberty County, Georgia. Charles Jr., a graduate of Princeton and Harvard Law School, was elected mayor of Savannah in 1860, before he resigned to serve in the Confederate army. Another son, Joseph, was a surgeon major of the Confederate medical department who researched medical treatments at Andersonville prison. His results helped condemn Confederate Captain Henry Wirz, the commander at Andersonville and the only executed Confederate commander after the war.

The Joneses, with their three plantations, were among the wealthiest and most prominent of all Georgians. Their plantation lives have been forever documented in *Children of Pride*, edited by Robert Manson Myers, a collection of thousands of family letters from pre- to post-

Civil War. The book was reworked into a biographical epic by Erskine Clarke in a multivolume set entitled *A Dwelling Place: A Plantation Epic*.

My story starts with daughter Mary Jones Mallard, who escaped from Atlanta during the siege to travel to the safety of the family's Midway plantation. During her escape she fell from the carriage and broke her collarbone. She was pregnant and feared for the health of her unborn child, foreshadowing what was to be a long, difficult and life-threatening labor. Her husband, Robert Mallard, had followed in the footsteps of his famous father-in-law and become a Presbyterian minister, serving as a chaplain for the Confederate army during the war. He was captured at Walthourville in Liberty County (now the land occupied by Fort Stewart) and, while captive, preached to the Yankees before he was paroled.

In mid-December, at Montevideo Plantation in Midway, where mother Mary and daughter Mary were staying, Yankee bummers and "serious foragers" came "flying hither and thither." By the time Sherman's army made it to Savannah, they were hungry again. The sandy, swampy lands of eastern Georgia did not produce the bountiful crops they'd encountered early in the march. They were desperate and quite skilled at foraging. Kilpatrick's Federal cavalry was generally thought to be the most savage of the foragers, and probably were the ones most responsible for the damage to the Joneses' property.

At Montevideo, invading Yankees demanded Mary Jones's keys and then proceeded to inspect even the tiniest of her boxes. After failing to find any treasure of worth, they took the locks of her children's hair she'd saved since their childhoods and scattered them on the floor. They took a number of chickens and ducks that had been prepared for the family and tore them to pieces with their teeth like ravenous beasts, proclaiming their intention to starve out all the Rebels. One barrel of rice was left for the family and some grain spilled on the floor. Out of desperation, they picked up the rice, grain by grain. An old mule was taken, only to be released for being too lame. It faithfully found its way back home. In the slave quarters, the family's young cook disguised herself as an old woman to escape Yankee rampage. Another dissuaded the soldiers from entering by claiming there was yellow fever inside. Yet another stopped soldiers from stealing her clothes by claiming they came off the backs of dead people. "We look back upon their conduct in the house as a horrible nightmare, too terrible to be true," recalled Mary Jones Mallard.

Sometimes mother Mary used entreaties to the Yankees; sometimes she espoused her belief in the Southern cause. She felt her greatest achievement in facing the invaders was that she never behaved in a cowardly manner. "We were completely paralyzed by these villains." She called them "fiery flying serpents."

Daughter Mary's labor began on January 4 and while the Yankees were still invading their property, they attempted to enter the birthing room itself. Mother Mary barred the door. It was a difficult labor. A doctor managed to make it to the house, only to announce the situation was grim. Mother Mary said to save her daughter over the child, but thankfully both survived. A healthy daughter entered in the midst of Yankees coming and going. They named her Georgia.

After their house had been searched three times, the women begged an officer for a guard. He said so far as his authority extended with his own men, none of them should have entered the house. Men were ordered to take provisions outside the house only. He was shown the damage that had already been inflicted "inside" the house. He was appalled and immediately a guard was provided. He commented, "I only wish I was here to guard you always." The visits from Yankee foragers continued for several more weeks.

## CORNELIA E. SCREVEN OF DORCHESTER

Cornelia E. Screven was a widow with a houseful of young children and a visiting niece, Miss Maxwell from Athens, Georgia, all living in the little village of Dorchester, near Sunbury, in Liberty County, just five miles from the Atlantic Ocean. Cornelia's sixteen-year-old son was with the Confederate artillery in Savannah. She was wild with apprehension about him as she heard the news of the Yankees' fast approach.

It was December 18, 1864, when Lieutenant Conyers of the Confederate army rushed past on horseback. Cornelia called out to him, "Can you be retreating?" He replied, "It is madness to contend with such tremendous odds." She asked, "Then how shall we receive the Federal soldiers?" His answer, "With dignity…conceal all of value…and may God protect you." And he was off.

Cornelia began to hide the valuables, collecting her silver and jewelry and placing them in a slit she made in the haircloth sitting

room sofa. She slipped in fifty-four pieces of silver, mostly spoons and forks, then hid a tea set in an old box, and placed a few old copies of the *Southern Literary Messenger* on top of the box to make it look natural. She locked up her dressers and closets, put the keys in her pocket and waited for the Yankees to come.

They came in droves over the next few weeks and she had many tales to tell of how she faced and fended off the invading Yankees. Two of her first visitors from the North were Adjutant Mitchell and Lieutenant Baker of the 5th Kentucky Regiment. They came asking for a glass of water, were filthy and ragged-looking and apologized for their appearances. Their demeanor denoted they were gentlemen. They asked for her permission to call in the morning, to see how the family had fared and to offer her protection (no doubt from what they knew possibly lay ahead, especially from stragglers). She thanked them and invited them to return.

In the meantime, other Yankee soldiers or stragglers came who were definitely *not* gentlemen. They demanded her keys, pulled her clothes out from the drawers, cut up the garments and trampled on them. The ringleader paused to catch a glimpse of himself in the mirror. Forgetting everything else, he took up a hairbrush and proceeded to rearrange his "fiery red bristles, which stood up like quills upon a fretful porcupine." Cornelia wrote that she could never forget the picture of him in the mirror, with his fine stolen silk hat, a ragged coat made of three different patterns of carpeting, pants with the knees out, shoes with the toes out, gazing intently at his own appearance. Suddenly someone called him from below and the spell was broken. The invaders departed to "commit the same depredations" upon other houses.

When Adjutant Mitchell and Lieutenant Baker returned, apologizing that they could not have returned any sooner, they looked much better from the obvious benefits of a bath. They were invited to sit on the sitting room sofa, where the fifty-four pieces of silver were hidden. What followed next must have seemed like a comedy skit. Bowing politely, they both took seats on the sofa. Lieutenant Baker was apparently a very heavy-set man, and as he sat down, the sofa jarred considerably. With one roller missing from the bottom of the couch, the silver jingled. Both officers looked around suspiciously. Miss Maxwell, Cornelia's visiting niece, placed two chairs for them to sit on, making her excuse, "The springs of our sofa are so loose,

perhaps you'll find these chairs more comfortable." They rose to take on the chairs and again the silver jingled. They glanced at each other with an amused expression. This was near the end of the march and doubtless they had experienced many such episodes in many other homes where the family silver had been hidden in the sitting room sofa. But being the gentlemen they were, they said no more.

Before they left, they gave Cornelia a Bible they had found in a Southern soldier's knapsack. His name, James Campbell, was written in the Bible. They asked that she see the Bible was returned to Mr. Campbell. Adjutant Mitchell added, "I hope when this war is over we will be a land of brothers again and none will welcome the day more joyfully than I." Cornelia said she'd gladly return the Bible. In a few days' time, the two men came back to announce they were pulling out and would not be coming back to visit. It was indeed a final visit for Adjutant Mitchell, as he was killed in March of 1865 at the Battle of Monroe's Crossroads near Fayetteville, North Carolina, just before the surrender by General Joe Johnston. His commander, Colonel George Spencer, praised Mitchell as being one of his finest commanders.

Then came the wretched hog thief and his gang, the lowest of the low as far as Cornelia was concerned, who took every bit of food he could find, even though she pleaded with him to leave some for her family. The thief replied, "I don't care if you starve; get out of my way or I'll push you out the door." She nearly fell over backward as he turned to go. Her niece couldn't hold her tongue and shouted out, "Oh you intolerable brutes! If I was a man I'd blow out every particle of your brains; if I had a pistol I'd do it anyhow, woman as I am."

They were rescued this time by a brave little champion named Hughes who said, "Ladies, I am at your service." He drew his revolver and kept the hog thief and fellow brutes from doing more damage. Cornelia and her niece sat down after this latest episode and began to cry. Hughes looked at the ladies in distress and stammered, "Ladies, d-d-don't cry. I never saw a woman cry in my life but what I had to cry too." And he wiped away tears from his own eyes with the back of his hand. The women were so touched that they burst out laughing. All of a sudden the idea of two Southern women and a Yankee soldier crying together seemed so ludicrous. Who would have ever thought it? Soldier Hughes, from Pennsylvania, left that night and they never saw or heard from him again.

But the hog thief returned one night, drunk and reveling around the Screven piano and the famous sofa. Cornelia had a fourth Yankee champion that night who was named Coffie, from Kentucky. He skillfully managed the exit of the hog thief and other rabble-rousers and gave Miss Maxwell a pistol for protection. She placed it in the piano for safekeeping. Then she noticed a pocketbook lying on the sofa in the very same spot the hog thief had been sitting. It contained thirty greenback dollars, sixty-five dollars in Confederate scrip, a set of goldstone jewelry, some steel pens, postage stamps and a due bill, which revealed his name: James Pope. Her children added "HOG THIEF" to the envelope. Then they found a love letter that read:

> *Dear Jim: I have bin a crien ever sence you are a goin to the wars...don't let them rebble injuns kill you...Your luvin Sally Ennis*
> *P.S. What was that you drump* [dreamt] *about me?*

Cornelia surmised the contents of the wallet and the priceless entertaining love letter more than made up for all the damage the hog thief had done to them.

January came and the Yankees left, except for a last few stragglers. The Screvens had two final visitors who came to demand a last supper. But the women had no food to give them, and the soldiers came to taunt them. "Miss Maxwell, how long do you think this war will last?" The niece replied, "Until the South is victorious." He replied, "The South will be conquered at an early day."

Then she loosened her vehemence on him, "Never! You don't know the women of the South. They will dig one common grave and lie down and die in it before they will call their husbands from the field, but with oyster banks to the right and palmetto roots to the left, we will live and defy your cowardly tribe, renegades and all." And with that she swept from the room with the air of a queen, or at least a Southern belle.

Cornelia's true triumph came when her son returned home from the war, safe and unharmed. "Our joyful hearts overflow with gratitude for this great blessing which brought once more to our little family circle peace and contentment."

## Getting Too Personal:
## Stories of Valuables Hidden on One's Person

Mrs. Naomi Bales lived on a plantation in Chattooga County when the invading Yankees (she called them the "wagon dogs") came to call. Those soldiers who had previously come to loot had hand carried their bounty. The latest ones carried away their plunder by the wagonload.

Naomi had several thousand dollars in Confederate money tucked away in a bustle around her waist and her small amount of jewelry and a few keepsakes hidden in huge pockets under her hoops. Her sister had sewn pockets beneath her hoops to contain the family flatware and jewelry. Apparently no one expected the Yankees to conduct a strip search. And apparently they did not, as the Baleses' hidden treasures remained in the family for generations to come.

<div align="center">❧</div>

Mrs. Hattie Brunson Richardson was a child living in Brunson, Georgia (named after her family), when the march came their way. The family prepared to leave on a caravan to the Upcountry, but decided to stay and face the Yankees. The word spread that homes were often spared if they were occupied and the occupants offered no resistance. So they unpacked and hid what they could. Food and articles of value were hidden in walls or buried in the lot and covered with manure. The oldest daughter, who was fourteen, took her father's much prized watch and hid it beneath the gnarled root of a large tree. All the daughters saved their best-loved china dolls by hiding them on their persons. They heard that Yankees would take the food right out of children's hands, so they hid food under their skirts. (There are some stories of ladies hiding the cooking pot, filled with hot soup or stew for the family's supper, underneath their hoop skirts for safekeeping.)

The Brunson house was pillaged. Once an officer came to their house, looked at all the damage and asked if soldiers had done this. Mrs. Brunson, normally a quiet and retiring woman, replied abruptly, "You don't think I did it, do you?"

# Approaching Savannah

❦

Emma J. Prescott lived in Clay County when she heard the Yankees were coming and would arrive by dinnertime. She rushed around, trying to find good hiding places. She hid the silver under the house, but the $500 in gold was too heavy to hide in her pockets. She was panic-stricken where to hide it and out of desperation dropped it into a trunk and hid the key. She was fortunate to be in an area where only a small band of raiders came through, and her items were safe.

❦

One woman of Talbot County put her silver and jewelry in a deep box and put it under the hen nest where the hen was setting. She had some thread warped and ready to put in looms to weave (representing many hours of work) and carried that to an old neighbor lady who was sick in bed, asking her to put the thread under her mattress. The old lady purportedly said when the Yankees came to search her house, "You wouldn't want a poor sick woman to get out of bed, would you?" When the Yankees came to the weaving woman's house and found nothing, the grandma of the house was dragged around in an attempt to make her divulge the hiding places. She would not acquiesce.

❦

Inez James of Varnell's Station told of the time the Yankees "honored us with a visit. They stole a pair of new gloves of mine that I had just finished. I had turfed them and finished them off nicely. I regretted the loss of my gloves worse than all or our corn and fodder." She went on to report, in a letter to a friend, that at a neighbor's house, the Yankees took two to three dozen fine combs. The neighbor said, "They needed them more than I did." After the Yankees visited Inez James's home, her parting blessing to them was, "May itch lice, our worse respects, and a good thrashing follow them."

❧

Synthia Catherine Stewart, whose story is told in more detail in another chapter, and her sister Sarah were told to hide the new suit their mama had made for their father, who was off to war. They put it in an old saddlebag and stuffed it into a hole in a tree. Then they took their good pitcher, filled it with the family silver and carefully placed it in a hollowed-out stump. Then they took the family's china and placed it carefully around the pitcher. They covered the stump with pine straw to make it look "more natural." After the war, when they returned home, they retrieved the suit, finding no moth holes, and also the china, pitcher and silver without a crack or a scratch to harm any of it.

## The Nancy Harts: Women's Home Guard of LaGrange

With the men off fighting, the women of LaGrange, Georgia, in Troup County, recognized the vulnerability of their beloved hometown. Located halfway between the former Confederate capital at Montgomery and the gateway city of Atlanta, LaGrange was divided by the railway line through the center of town that made it a vital link for Confederate supplies. The war was winding down but there was a new danger of attack by stragglers from both armies and the ever-present possibility of a Federal raid.

Southern women often said that those who stayed behind found it harder than those who left to fight, for they were the ones left to defend the Southern way of life. "If only I were a man," thought Nancy Colquitt Morgan, only twenty-one and married to a lawyer now serving in the 4th Georgia Infantry. Two of her brothers also served in this unit. Her younger brother was killed at the Battle of Fredericksburg.

Mary Cade Alford Heard, twenty-seven, and a classmate of Nancy Morgan's at LaGrange College for Women, also had a brother killed in the war and a husband, Peter Heard, also off fighting for the cause, leaving her behind to tend to both their own and her mother-in-law's plantations and to supervise over one hundred slaves.

The women felt useless in the war effort, even though they tended to the wounded in nearby hospitals. But they didn't stay useless for

long, as the two women banded together to form a home guard. Nancy was made captain (ironically giving her a higher ranking than that of her husband) and Mary became first lieutenant.

They called themselves the Nancy Harts, after Nancy Morgan Hart, Georgia Revolutionary War heroine and the only woman with a Georgia county named after her. The story goes that Hart, angered over the killing of a Patriot neighbor by raiding British soldiers, was forced to cook a turkey dinner for these same red-coated murderers. But when the men sat down to eat, Nancy managed to remove most of their muskets, one by one, through a chink in a hole of her log cabin. When her thievery was discovered, she aimed one of the muskets at the British soldiers. Unsure of whom she was aiming at (for as the story goes Mrs. Hart was quite cross-eyed), a soldier made a move and was instantly killed by "War Woman," the name the Indians called Nancy. The rest were rounded up and later hanged by Nancy's husband and a few other local Patriots. Nancy Morgan Hart was an appropriately inspirational role model for Nancy Morgan (no known relation to Nancy Morgan Hart) and Mary Heard.

They announced the formation of a female military company for the defense of their fair city and gave notice of a preliminary meeting at the old red schoolhouse in Ben Hill's Grove. Some forty women responded to the call, and thus the Nancy Harts came to be. They were trained by Dr. Augustus C. Ware, a local practicing physician, who could not fight in the war due to a physical disability. The women wore loose skirts and tight jackets with gray buttons painted to look like those on their husbands' uniforms.

They met twice a week for target practice. Captain Morgan carried her grandfather's flintlock rifle and Lieutenant Colonel Heard used a musket her husband had rejected. The rusty weapons the women used, some say, were potentially more dangerous to the women than fighting in a battle.

The "Nancies" carried on with their drills and target practices in Harris Grove and at the Bull Pasture, soon overcoming an instinct to automatically close their eyes when shooting at a target. There are two amusing stories that follow of early incidents, as the women learned to be skilled marksmen.

Some of the women were terrible shots. It was not unusual for a neighbor's cow or horse to come up limping after target practice.

In fact, the only killing the Nancies ever did was of Judge Orville August Bull's family cow.

One timid Nancy, at the command to fire, reportedly turned her head away, shut her eyes and blindly fired. The ball struck a grapevine and stirred up a hornet's nest. The hornets rose to the attack and charged after the women. Target practice was probably cut short that day. But the women quickly improved and turned into steady and reliable markswomen.

Although formed in 1861 at the beginning of the war, the Nancy Harts did not see action until Easter of 1865. The word hadn't spread yet to south Georgia of Lee's surrender to Grant at Appomattox Courthouse. Federal Brigadier General James Wilson was also unaware of the surrender. He was eyeing the key railroad bridge near Fort Tyler by the village of West Point, figuring it to be an important asset to the Confederacy and so needing to be destroyed. He sent artillery units and three thousand cavalrymen to raze it.

Word quickly spread to the available men in the area that the Federals intended to attack Fort Tyler. All the men were rounded up as Confederate Brigadier General Robert Tyler led the defense. General Tyler was killed. Three hundred defenders would not last long against three thousand Federal attackers, who were part of some thirteen thousand troops under General James Wilson of the Union Military Division of the Mississippi, better known as Wilson's Raiders.

Meanwhile, back in LaGrange, the Nancy Harts were concerned about the trouble at West Point and the pending danger to their town. Many of them had loved ones, husbands and sweethearts involved in the fray. They worried that the Federals would next move to attack LaGrange, and that is just what happened. The Nancy Harts were called to action for the first time in the defense of their city.

They grabbed their rusty weapons, put on their ladylike uniforms and marched, some forty strong, to the tune of "Dixie" to meet the Yankees head on. A cavalry regiment of Wilson's Raiders advanced, led by Colonel Oscar LaGrange. (His name, the same as the city he approached, was purely a coincidence.) The women held their stance, but were dismayed to see many of their husbands and sweethearts now held captive by the Yankees. One such captive was Major R.B. Parkham (also spelled Parham and Parkman in various accounts).

Fourteen-year-old First Corporal Leila C. Pullen of the Nancy Harts approached Major Parkham and said, "Major, I regret

to see you in this plight." Colonel LaGrange asked, "Is he your sweetheart?" "Yes, he is," was her reply. LaGrange's was, "Such honesty deserves reward; I will give him a parole and allow him to spend the evening with you."

Then Major Parkham, now temporarily freed, spoke, "Colonel LaGrange, I have the pleasure of introducing you to a regularly commissioned officer of the Nancy Harts."

Colonel LaGrange then uttered his now famous words, "I should think the Nancy Harts might use their eyes with better effect upon the Federal soldiers than their rusty guns."

Then the women, believing it a good policy to appease the enemy, broke ranks and invited the Federal soldiers to dinner. Colonel LaGrange gladly accepted and, being a kindly gentleman, even in times of war, placed guards around some of LaGrange's most famous homes. Perhaps in his mind's eye, he was protecting his namesake town.

Some of the stores in town were looted. The local tannery, cotton warehouses, train depot and some buildings around the town square were destroyed. Interestingly, Bellevue Plantation was not destroyed. It was the home of prominent Confederate and former U.S. Senator Benjamin Harvey Hill (no known relation to Joshua Hill, also a U.S. senator and mayor of Madison, Georgia, and mentioned in this book). It was the usual custom to burn homes of high-ranking Confederates, but Colonel LaGrange had a soft spot for the Hills. A niece of the senator had tended to the colonel when he was seriously wounded and captured by the Confederates in the spring of 1864. Colonel LaGrange recovered and became part of a prisoner exchange in the fall. He never forgot the favor and so the Hill home was spared.

The LaGrange women, including the Nancy Harts, were busy that night cooking for the Yankee regiment and the hometown prisoners of war. It was a sad morning the next day, when those beloved prisoners left with the enemy. But the sadness was short-lived when Colonel LaGrange and company arrived in Macon, heard news of the surrender and immediately released their prisoners, who quickly returned home to a hero's welcome.

The story goes that Colonel LaGrange was smitten by a Macon girl and eventually married her and took her to his Wisconsin home. Before they trod back North, Colonel LaGrange, as an

officer and a gentleman, presided over a wedding ceremony of one of the Nancy Harts and her sweetheart. But it was not Leila Pullen marrying Major Parkham, as you might expect. She ended up marrying James A. Morris of Morristown, Pennsylvania, whom she met after the war.

There were other women's militia groups throughout the South, usually connected to women's academic institutions. But in some circles it's the Nancy Harts who are compared in bravery to the noble Trojan women.

A Georgia state historical marker located at the Troup County Courthouse in LaGrange is dedicated to the Nancy Harts. The marker summarizes the story of their confrontation with Colonel Oscar H. LaGrange and the 1st Wisconsin Cavalry on April 17, 1865. The last paragraph offers the most fitting testimony to them:

> *Seeing the charmingly militant array formed to meet him, Colonel LaGrange complimented them upon their fearless spirit and fire martial air and, after a brief delay, marched on toward Macon, leaving no scar other than the broken railroad to deface this gracious Georgia town whose name he chanced to bear.*

The Nancy Harts never had to say they were useless. They used their feminine wiles and successfully stood their ground, defending the town of LaGrange, Georgia.

## The Battle of the Homestead

There are numerous stories from family folklore that fall under the "Battle of the Homestead" category. How far would a Georgia woman go to defend home and hearth? These stories are not for the timid.

❧

Minerva Moore Hughes of Walton County, Georgia, was a widow left with nine children to raise. The family milk cow meant everything to her. When the raiding Yankees were coming, she had the children take the family cow and hog to the gorge, where they tried camouflaging them with tree branches.

When the Yankees came, they took all the corn. They knew there had to be animals on the farm, so they left two soldiers behind to look for them while the rest moved on. One soldier remained inside the house and one went outside. Minerva distracted the one on the inside while she loaded up her double-barreled shotgun. When he came back in, she shot him. When the one outside heard the noise, he came rushing back in. She shot him too. It was all to save the family cow and hog.

But what to do with the two dead bodies, since she knew they'd be missed? She had one of her sons take the Yankees' horses and turn them loose. To hide the blood on the floor, she and the children refloored the entire kitchen with new pine boards. Then they buried the two Yankees—all in a day's work. Apparently they were never found out.

<div align="center">᧞</div>

Another story tells of a stick placed in a window to hold it up. When a Yankee soldier peeked in the window, the woman of the house pulled out the stick, causing the window to fall down on the man, breaking his neck.

<div align="center">᧞</div>

One woman reportedly took a chink out of her cabin wall, placed her musket in the hole and shot a soldier coming for her food. This same woman, after firing, put a spindle through the chink, causing another hungry soldier to impale himself.

Another woman took a butcher knife and cut off the hand of a soldier reaching for her corn. This was a lady of determination who would not let her family starve. To add to the marvel of her feat, she was described as being only ninety pounds when soaking wet.

<div align="center">᧞</div>

These were just some of the Civil War Nancy Harts whose passion was unleashed over their zealous love for home and family.

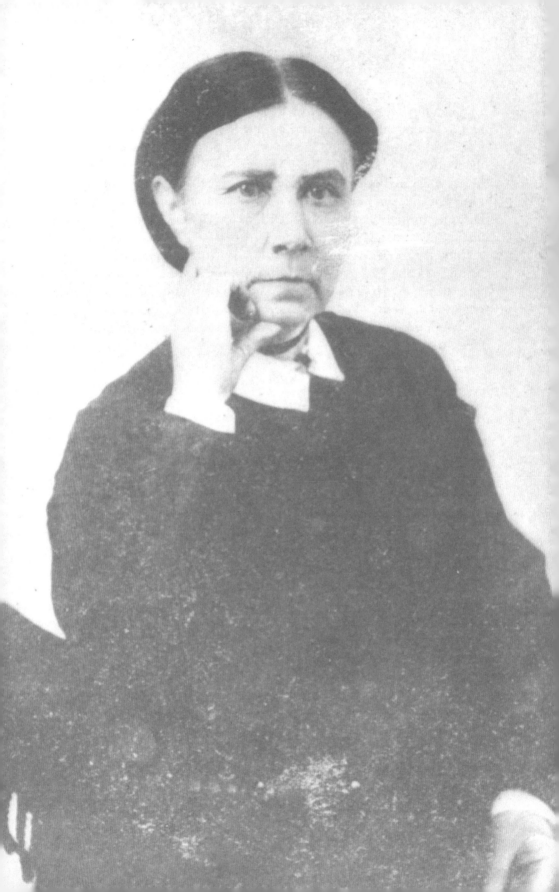

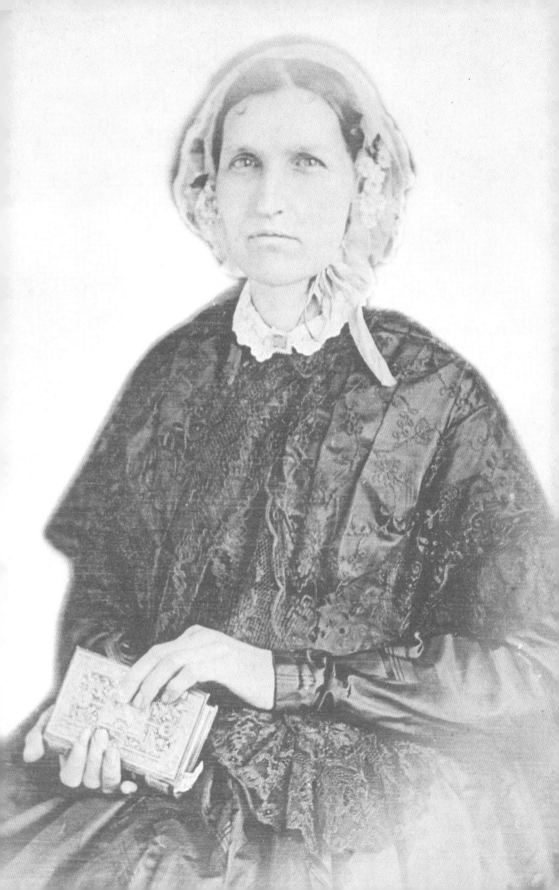

*Chapter 5*

# Triumph in Savannah

The war was winding down, Sherman believed, and it was not necessary to capture General Hardee's troops. General Hardee himself said it was his best act, pulling out of Savannah before Sherman arrived, thus avoiding a major and devastating conflict. With the capture of Fort McAllister on the outskirts of Savannah and the escape of General Hardee's men across the Savannah River via pontoon boats, Savannah now belonged to Sherman and the Union army.

The Confederate forces skipped out on December 20. By Christmas, the Union army occupied the city. It was a curious coincidence that at Christmastime 1778, the city had been captured by the British, and now, at the same time in 1864, by another enemy.

General Sherman took up residence in the home of Charles Green, an English cotton merchant who brought in medical supplies for the South from England. His son was a Confederate soldier. He offered his house to the general to spare a Georgia citizen the indignity (and he hoped to spare the many bales of cotton in his warehouses—they weren't).

Citizens in Savannah were hard up when the Yankees came, and having sixty thousand hungry, homesick Yankees in town

brought out the crafty entrepreneurial skills and cunning of many a woman in Savannah. The Yankee soldiers had money to burn (they were finally paid for the march) and were short on supplies. Most Savannah housekeepers had a knack for making pies and pastries. One local woman expressed, "These Yankees all want something sweet and we want some of their greenbacks."

Many basements turned into pastry shops, like that of Eliza Thompson of 5 West Jones Street (now a popular historic bread and breakfast in Savannah). Sherman, in his memoirs, made note of a Miss Josephine Goodwin (he knew her by this maiden name when he was stationed in Savannah before the war) who baked pies and cakes from flour and sugar she bartered for at the Federal commissary; she realized a profit of fifty-six dollars.

Elizabeth MacKay Stiles (Mrs. William Henry Stiles) didn't bake, but she made money by selling her jewelry and finery to Yankee soldiers to give to their wives and girlfriends. (The Yankees didn't pillage in town, just outside of town.) She also made survival money by selling bouquets of flowers. One Yankee soldier bought a full box of camellias, which bloom through the winter in the South, and shipped them off to his sweetheart in New York. Elizabeth bragged that she made thirty dollars a day—a fortune then—while the Yankees were in town.

Mary Randolph bartered with the Yankees with her fourth carriage wheel. Purportedly she rolled the fourth wheel up four flights of stairs to hide it from Federal soldiers who had taken her carriage. She bartered for beef in exchange for the fourth wheel. There are differing stories as to whether or not Colonel Barnum came through with his end of the deal. Most say more than likely not. Being a pushy woman, Mary apparently went to see General Sherman to get back her cotton that was taken from her. She went with two friends who refused to be introduced to the general. He reportedly found this amusing, as they were heard to say, "I don't want him [Sherman] to rest comfortably but wish a thousand papers of pins were stuck in his bed and he was strapped down on them."

Northern soldiers were fascinated by Savannah women. One soldier proclaimed, "I swear I was never so bewitched before." It was true that some women used their charms to further their own agendas or, in Southern words, "buttering the Yankees well to serve our own ends."

# Triumph in Savannah

In his memoirs, Sherman thought it strange that while in Savannah, General A.P. Stewart's wife came to him, General Hardee's brother and others of strong Confederate connections, to ask for aid and favors. "They do not seem ashamed to call on the 'Vandal Chief.'" Yet all the papers proclaimed that Sherman and his men burned everything in sight, killed the men and ravished the women. Obviously those in the know, in the high-ranking positions of the Confederacy, knew these to be exaggerations in the extreme.

In truth, while under Sherman's care, the city of Savannah fared better than it had in quite a while. Schools and stores reopened, churches filled, commerce resumed and destitute families got food from the Federal stockades. Furthermore, people from New York, Boston and Philadelphia sent food to the residents of Savannah, taking pity on them as word of the march reached Northern papers. Some Savannahians, although taking advantage of the aid, retorted, "They think they are so liberal, giving us food, and yet they stole from one Georgia plantation more than there is subscribed in the whole of New York." The Union army stayed until February 1, 1865.

## FRANCES THOMAS HOWARD

The Reverend Charles Wallace Howard established a plantation near Kingston, Georgia, with an in-town home in Savannah (as was the style of the day), with his six daughters and at least one son and started a finishing school for girls. The Civil War interrupted his duties as headmaster, as he left to become a captain of the 63rd Georgia Division, serving side by side with his son, Lieutenant Jett Howard.

His daughter Frances kept a diary and, along with a full house of five sisters, various nieces and nephews, servants and children of servants, kept the home fires burning in his absence. When the Federal army entered Savannah, Colonel Henry Barnum's men chose the Howard house to be their headquarters. Frances interceded, "But there are eight children here all under the age of five and I don't think you'll find a stay in this house very pleasant." Colonel Barnum's staff member quickly replied, "Good God! Eight under five. I'll go anywhere else!" It was a ploy that worked.

Her sister Susan, a Miss Moodie (who was related to the British consul) and Frances were concerned about Confederate prisoners who had been rounded up during the enemy occupation or during skirmishes along the march. They were placed in Savannah jails and the Howard girls, along with Miss Moodie, were concerned about the prisoners' care and what they were being fed. Like three musketeers, they went to visit Colonel Barnum's headquarters to apply for permission to feed these Confederate prisoners and to ask for a guard to protect the food. To grease the wheel, Frances invited the captain of the prison guard to dinner. He was astonished. "Why do you invite me to dinner when I am the enemy? You like us I suppose." She answered, "No, we hate you, as all good Confederates should. We thought once we've fed you, our enemy, then you can't refuse to let us feed our friends and so be it!" And so he couldn't refuse.

An old nursery rhyme that was a favorite of Frances's childhood nurse came in handy several times during enemy occupation (though slightly altered in a war version).

> *Ingin pudding and pumpkin pie*
> *Made dem Yankees jump sky high.*

Frances bought three pumpkins for twelve dollars in Confederate money and intended to test the rhyme. The rest of her money she spent on tobacco—not for personal use, but to sell to the Yankee soldiers, who had money to burn, at a nice profit. With the pumpkins she made pumpkin pies. With the tobacco sale, she bought sugar for the pies. The three musketeers made fifteen dollars in greenbacks, which tided them over for quite a while.

Some Savannah women, according to Frances, used their own charms to bewitch the Yankees and further their own agendas—"buttering them for their own ends," she called it. But Frances knew the way to a man's heart was through his stomach.

In 1870 she wrote of the Federal occupation in a book not published until 1905, two years before her death. The lengthy title read: *In And Out Of The Lines: An Accurate Account Of Incidents during the Occupation of Georgia by Federal Troops In 1864–1865*. The book was published by the Neal Publishing Company. Frances wanted to write the story of what happened in Southern homes during the occupation, but for some

reason, practicality or fear of notoriety, although the story is autobiographical, she renamed all the characters in her book. The book was reprinted in 1997 by the Etowah Valley Historical Society of Cartersville, Georgia.

## ELEANOR KINZIE GORDON

Eleanor (Nelly) Kinzie was the acknowledged belle of Chicago at the time of her Christmas wedding of 1857 to William Washington Gordon of Savannah, Georgia. The newlyweds settled into their antebellum home at the corner of Bull Street and Oglethorpe Avenue at one of the many beautiful squares in Savannah. Their first daughter Eleanor arrived in 1858, followed by Juliette (future founder of Girl Scouts of America) in 1860, a Halloween baby.

Soon followed the Civil War and husband William became a captain under Major General Joseph "Fighting Joe" Wheeler's command. Even though Eleanor Kinzie Gordon was born and bred in the North, had a father and two brothers in the Union army and another in the Union navy and was related by marriage to one of the most hated Union generals (General David Hunter), she was called one of the "rabid Southrons" who dwelled in Savannah. When Savannah belles told her they hoped her brothers would be killed in battle, her Southern fervor did not diminish. She was said to conceal a small pistol in her belt, beneath her coat, in case anyone gave her any "sass" about her loyalties.

Then William Tecumseh Sherman came to Savannah. Eleanor Gordon wrote that when the troops marched past Savannah homes, "everyone's shutters were tightly closed." But her girls, Nelly (Eleanor) and Daisy (Juliette), were curious about the encroaching Union army, particularly the leader who was called the devil himself.

Sherman's Letters Home:
My Dearest Minnie

*Memphis, TN, Aug. 6, 1863*
*Dearest Minnie:*

*Think of how cruel men become in war, when even your Papa has to do such acts. Pray every night that the war may end. Hundreds of children like yourself are daily taught to curse my name, and every night thousands kneel in prayer and beseech the Almighty to consign me to perdition. For I am thought of as the devil himself.*

*Your Absent Papa,*
*W.T. Sherman*

The two girls stood on chairs to take peeks through the blinds. Daisy, then four, supposedly asked: "Is that Old Sherman?" And Nelly replied, "I don't know. I've never seen him." But soon thereafter Daisy met Old Sherman, face to face.

He was an old friend of Eleanor Gordon's father, John Harris Kinzie of Chicago, now a lieutenant colonel in the Union army, and had known Eleanor from her childhood. When he arrived at the Gordon house, Eleanor said there was a little girl very anxious to meet "Old Sherman." Both girls blamed the other for the name-calling, making Sherman roar with laughter. According to folklore, Daisy, upon finally meeting him, asked him where his tail was, for after all he was supposed to be the devil.

Sherman missed his own family greatly and the Gordon children became substitutes for his own daughters. He put them alternately on his knee and kept them in shouts of laughter until way past their bedtime.

The general described the homey atmosphere at the Gordons' to one of his adjutant generals, O.O. Howard, who was also a strong family man and missed his five daughters. He asked permission to visit the Gordon household and Eleanor said yes. The following famous story took place during General Howard's first visit.

General Howard had smashed his right arm during the Battle of Seven Pines in 1862. As a result, it had been amputated, leaving his right sleeve hanging. Daisy questioned him about his missing arm. The general replied, "Are you not sorry for me?"

> DAISY: *"Yes, indeed, what happened to your arm?"*
> GENERAL HOWARD: *"It was shot off in battle."*
> DAISY: *"Oh did the Yankees shoot it off?"*
> GENERAL HOWARD: *"No, my dear, the Rebels shot it off."*
> DAISY: *"Did they? Well I shouldn't wonder if my Papa did it. He has shot lots of Yankees."*

Sherman and Howard were to visit the Gordons many times during their stay in Savannah. Sherman's men commented that the usually slovenly general was "dolled up like a duke" when he went visiting Eleanor Gordon said she didn't give a fig what others thought of her allowing General Sherman into her home. She would do anything to ease the burdens of fellow Savannahians, and

keeping the man in charge in good humor might keep him from inflicting further harm to her city.

The story goes that Sherman gave Confederate sympathizers in Savannah the option of staying in their homes or joining friends and families in other cities. Eleanor said she couldn't leave Savannah without the consent of her husband, who had retreated with the Confederate army across the Savannah River. Sherman offered his help, Eleanor being "a very accomplished and agreeable lady of Northern birth, but of Southern adoption." She received permission to travel to Charleston but had no money to pay for her trip. Eleanor was given part of a cache of Confederate money found outside Savannah that had been buried for safekeeping. This money was of no use to the Federals, but was offered to Eleanor. She accepted the money, which served her well, but angered her husband.

William Gordon was not in good humor when he heard of Sherman's visits to his home. He hated to see his wife and children behind Federal lines, but could accept that as a fate of war. But he could not tolerate his wife associating with his enemies under any other terms than being merely polite, as was the duty of any proper Southern lady. He wrote to her, "What galls me is that you should associate with MY enemies upon any other terms than those which politeness demands from every lady." It was certainly not a proper thing for her to do, to accept money from a Union officer. Eleanor eventually went to Chicago to be with her parents until the war ended.

## FANNY COHEN TAYLOR

Fanny Cohen, known as a bright little Jewess, of Savannah, Georgia, came from strong Southern stock. Her mother, Henrietta Levy, grew up in wealth in Charleston, South Carolina, in a family who strongly identified with the Southern cause. Fanny's aunt, Phoebe Yates Levy Pember, her mother's sister, was none other than the famous Phoebe Yates Pember, well known as a nurse, heroine, philanthropist and director of the Confederate hospital Chimorazo, in Richmond, Virginia.

Fanny's father, Ocatavus, settled in Savannah, where he became a successful and well-respected commission merchant and cotton reporter. His children grew up in prosperous times at their home on

Lafayette Square, at the northwest corner of Macon and Abercorn Streets. His son, Solomon, became a lawyer and postmaster for Savannah. Thus the family was well ensconced in Savannah life and politics.

Fanny was twenty-four and the wife of Henry Taylor of the Confederate army when Sherman triumphantly entered Savannah around Christmas of 1864. She did not call his entry "triumphant" and told a Federal officer, "Our city has not been captured, Sir. Your General Sherman only came here to save himself from being captured by General Hood. Our army was short of stores and General Hardee, who is a personal friend of mine, has merely gone away for supplies." The Federal officer thought otherwise.

She was forced to entertain Union officers one by one in her home. She rankled at the idea of it. "The anticipation of having them among us is enough to make us prematurely old." And later added, "I see no reason why we should receive our enemies as our friends and I never shall do it as long as I live."

Once a Federal engineer named Poe came to call. Fanny described his visit thusly, "I was obliged to receive him and never was so embarrassed in my life...My hatred for the Army in which he was an officer and my desire to be polite made me almost speechless—the contending feelings were more than I could control."

But still they came, in spite of her zeal for the Southern cause and icy cold treatments. She described the visit by Sherman's quartermaster, who had come to see her father: "I was obliged to receive him but did so standing up so that he could have no excuse for remaining longer than his business required him to do...He left like a well bred dog...I rather think he won't come again and I hope from the bottom of my heart that he won't come again."

General O.O. Howard wanted to use the Cohen home for his headquarters. Octavus told the general that there were ladies in the house and it would be extremely inconvenient for the ladies to move. He talked General Howard into occupying an empty house opposite them, but allowed the general to keep his horses in their stable.

In the end, Brigadier General William Babcock Hazen, whom the Cohens had known before the war, came for quarters. The Cohens gave up two rooms for his use—the front parlor and a guest bedroom. He was a trusted family friend and Fanny knew he would treat them with consideration.

She wrote that this was her saddest Christmas and that her only pleasure was to look forward to spending her next Christmas in the Confederacy. (The family, although Jewish and members of the temple in Savannah, must have celebrated Christmas.) She gathered a group of friends for "Rebel meetings" where they abused the Yankees to their hearts' content long into the night. On New Year's she mourned, "How sad this beginning of the year to us surrounded by enemies."

Fanny Cohen kept a diary during the Federal occupation, ending it abruptly on January 3, 1865, almost four weeks before the Federals moved out. Perhaps she'd come to realize that General Hardee was not coming back and that there would be no next Christmas in the Confederacy, and could not bear to write that grim truth in her diary for posterity's sake.

## Rosa Postell

Rosa Postell, christened Maria Monroe Barney, was born in Baltimore, Maryland. She was a granddaughter of Gunning Bedford, delegate from Delaware to the Second Constitutional Convention and one of our country's founding fathers. Her marriage brought her farther south to Savannah.

By 1864, her husband was a Confederate prisoner of war. She had a nineteen-year-old son who had been killed in the war, two more sons off fighting and five children still at home, including a teething baby, all who were dependent on her. Sherman's army now occupied Savannah. His men actively censored the mail that came in and out of the city. Rosa wrote two letters to her sons who were fighting away from home. The letters were intercepted by the censors, who said they contained impudent, possibly treasonable elements. As a result, she was ordered to see the provost marshal.

General Grover sent orders to the provost marshal that Rosa was to be sent "out of the lines" by noon the following day. Those were rather harsh orders for something as simple as "impudent letters." She thought, how could she be put out, with four young children and a sick baby? The marshal told her to report at nine the next morning to speak with the general. The rest of that day she made preparations in anticipation of her removal, thinking she'd probably

have to go to Augusta. She couldn't go to her husband's people in South Carolina. Sherman was advising Savannahians asking for passes to South Carolina that he and his army were soon headed that way and "woe to every living thing found in the state of South Carolina." So she thought Augusta to be her only alternative.

The next day she told General Grover she had a right to the sentiments she expressed in her letters.

> *I had only spoken the truth…that the South had been wronged and the North had been the aggressor. For after all I am a Southern woman, Sir. I was SOUTHERN born* [Baltimore being below the Mason-Dixon line was considered Southern to many], *SOUTHERN raised, and every sentiment of my very soul is SOUTHERN.*

(It can be noted here that her grandfather Gunning Bedford voted for a Confederation form of government at the Constitutional Convention rather than the Federation form that won out, and was a strong supporter of states' rights.) General Grover asked her to take the oath of allegiance and once taken, she and her family would be allowed to stay. Her reply was, "No Sir. I have vowed before heaven I would never cross that ocean of blood in which my boy's blood mingles" (referring to her son killed in the war).

She continued:

> *Look at these hands, these swollen knuckles from rheumatism from being at wash tub and cook pot. Letters written under such grievances could be no other than expressions of indignation and hatred of a cause pursued against us.*

Then she called in Dr. Arnold, who had been treating her baby, as a witness to the truth of her baby's illness. (The baby was actually teething and not seriously ill.) Her final plea to the general was to make her a prisoner in her own home. She said, if allowed to stay, she'd accept the ultimate punishment and would agree to "make my tongue be shut."

She was given three more days to comply and take the oath. However, on the second day, her cousin Emma brought three of Rosa's children (Bessie, Rosa and Predee) to see General Grover.

# Triumph in Savannah

As he looked at the three darlings, she asked how he could possibly send these three precious children out into the cold. He softened and asked how the baby was. "Better," she said. Then he agreed to let Rosa Postell and her family stay in Savannah.

Eventually Rosa took the oath so that she could receive and send letters, something that turned out to be far more important to her than the "lost cause." At the war's end, she wrote her husband, not yet released from his prison camp, that when he returned home, she hoped they'd move abroad to go "far away from the horrors that await us here." (She, like many other Southerners, was wary about the Reconstruction days to follow.)

## Two Savannah Women and the Union Flag

Florence Vernon Stiles, called "the queen" by her gentlemen friends, was the quintessential belle who never raised her voice or revealed her ire, except when Sherman was mentioned or when her beloved South was held in low regard. With the occupation of Savannah by Union forces, it must have been difficult for her to hold her temper in check.

When Sherman's men placed the Union flag on the west side of Bull Street, she was outraged. No self-respecting Savannah lady would walk on the east side of Bull Street because that's where the soldiers' barracks were. Putting up the flag on the west side of the street forced Savannah ladies to walk under the Stars and Stripes. Walking under the Union flag meant honoring the Union and dishonoring the Confederacy.

Florence refused to walk under the Union flag and was so upset when she returned home that she went straight to bed. Within an hour there was a sharp knock on her door. A Yankee soldier rushed in and demanded to see Miss Stiles. He had orders from his commander for her to leave Savannah at once. Either someone had seen her refusal to honor the flag or heard her rampage and reported it to a commanding officer. This was a "treasonous act."

Florence's servant said she was too ill to leave her bed. The soldier was shown to the bedroom to deliver his message and to see proof of her illness. When he delivered the orders, she said no Yankee could make her leave, letting her voice rise in anger. He retorted that if

she truly were sick, she wouldn't be able to talk so fast and so sassy and look so fine.

She would not budge, so he finally gave up in defeat.

❦

Another Savannah lady stepped onto the sandy street (cobblestones had been removed and dumped into the harbor, making it difficult for Union boats to enter or leave). She was trying to avoid passing under the Union flag. Unfortunately, this flag was flying outside of General O.O. Howard's office and her "disrespect for the Union flag" was seen. She was taken to General Howard for questioning. The questioning went like this:

> GENERAL HOWARD: *Did you refuse to pass under the flag?*
> ANONYMOUS BELLE: *Yes, am I not at liberty to walk in the sand if I prefer it to the sidewalk?*
> GENERAL HOWARD: *Yes, but you intentionally avoided my flag. I will make you walk under it.*
> ANONYMOUS BELLE: *You cannot make me. You'll have to carry me and it will be by* YOUR *act, not mine.*
> GENERAL HOWARD: *Then I will have you arrested and sent to prison.*
> ANONYMOUS BELLE: *Then send me. I know you have the power if not the right.*
> GENERAL HOWARD: *Then I'll have the flag hung under [sic] your door so you'll have to pass under it.*
> ANONYMOUS BELLE: *Then I'll stay at home and send the servants out.*

Obviously this would have gone on for many more rounds. So the general gave up and the woman was released.

## KATE: A SAVANNAH TRAVELER

Mrs. C.E. Means from South Carolina wrote an article in *Our Women in the War*, a touching account of her Aunt Kate, who traveled from Columbia, South Carolina, to Savannah to bring home her gravely

# Triumph in Savannah

ill husband, a prisoner of war since the Battle of Gettysburg. I include her in this book, even though she was a citizen of South Carolina, because she so nobly represents one of the best examples of Southern womanhood and her story takes place in Savannah.

Kate was, by all accounts, a happily married woman, devoted to her husband and three young children. But when he went off to fight for the "cause," she was left alone to fend for the family. She wrote her husband daily, after the children were tucked in for the night, consulting him in regard to all matters, never relaying any of her own troubles. He wrote: "Kate doesn't let me get homesick." As many devoted wives did, she sent him provisions every few weeks, her edibles earning her the reputation of "best wife in the regiment." Her husband's last visit home was shortly before the Confederates advanced into Pennsylvania. When he left, she was filled with foreboding, soon heightened by the news that he was missing in action. She never gave up hope that he was yet alive, although her countless searches were in vain.

In December of 1864, Kate received a letter, obviously written by a tremulous hand, but she recognized it immediately as her husband's.

> *I am exchanged, have been for months at Ft. Donaldson. From the cold, cruelty, and starvation encountered there, I am nearly dead. Come to Savannah to meet me. I may, God willing, live to see you once more.*

She took her children to stay with her father and began the trip to Savannah, not an easy task with troops everywhere, closing off roads and preventing passage from anyone outside the army. With persistence, she received a pass to Savannah. When she arrived, the city was in a state of great confusion as Sherman and his troops had arrived just a few days earlier. She began looking for the place where sick Confederate soldiers were housed and was led to a hospital full of wards, with no one in authority to lead her to her husband.

It was a pitiful and frightening experience—viewing the condition of these men. She heard a weak voice call out her name. She found her husband, only, she thought from looking at him, to see him die. But she vowed to take him somewhere else to die—not in a

common hospital. A pastor from one of the local churches gave her a room in his large parsonage, helped her move her husband and then helped her get food and fuel. Her intent was to get him strong enough to take him home to die, for his one wish was to see his children again.

She went to the Federal commander at the docks to ask him to help her get transportation home for her dying husband, who was an exchanged prisoner of war. Not only did the commander give her transportation on the boat to Port Royal, but he also provided an ambulance to take them both to the wharf. He also detailed a soldier to escort them. No man could be unmoved by her sad story. Kate, although she knew it was too late for her husband to survive the cruelties of war, was grateful for all the help she received from strangers and from the enemy during her hour of need.

Along the way home, they stopped at a wayside home, one of the many stopping places designated to dress wounds of the injured soldiers, provide rest for the wounded and dispense necessary medicines. Kate stopped at a mission run by a Mrs. Roe. They reached Columbia and her father's house where her husband was reunited with his children. He died two days later.

*Conclusion*

# Three Last Letters

A nd so they came—the men of Sherman's March, beginning on November 15, 1864. They reached Savannah on December 21, 1864 and stayed until February 1. Certainly it is difficult to account for the vast amount of damage done to the state of Georgia. One soldier estimated that one hundred thousand hogs alone had been killed during the march. The state's cotton crop and supply had been decimated or sold to fill the coffers of the Federal government. Beyond the state, the Confederate army in Virginia was suffering from lack of food, their food supply having been destroyed in the march. Thousands of Georgians were left homeless and destitute and without sustenance.

But it is even harder to take into account the psychological damage— the kind that is not easily fixed. Such is the result of war. And no war can be worse than a civil war. "For behind they left a wailing, a terror and a ban." The wailing was to be heard for generations to come.

This book is a testament to the bravery of the women of Georgia. When put to the test, many Georgia women found the inner strength to face their adversaries. With the stories in this book, we are reminded of their courage, wit and fortitude, but, most of all, of their love for the sanctity of home and family. I conclude with these closing letters.

## Sherman's Letters Home: My Dearest Ellen

*Savannah, December 1864*
*Dearest Ellen:*

*As it turned out, Savannah was the true prize of the march, not the Rebel army. I gave the city of Savannah to President Lincoln as a Christmas gift. In little more than a month we had made it across the state of Georgia. I estimate the damage my army did to Georgia's resources was one billion dollars. My army had wrecked more than 300 miles of railroad, leaving Sherman neckties in 40 counties, burned numberless buildings—public and private. My men had been a little loose in foraging…but they had marched to the sea with as little violence as could be expected. This may seem a hard species of warfare, but it brought the sad realities home to the rebels. My heart bleeds when I see the desolation of homes, the bitter anguish of families. But now judges pronounce this as among the grand deeds of the world…I do more than ever crave for peace and quiet, and would gladly drop all these accolades and gather you and my little ones in some quiet place where I could be at ease…*

*Affectionately yours,*
*Sherman*

*Camp on Bear Creek, 20 m NW of Vicksburg, June 27, 1863*
*Dearest Ellen:*

*I doubt if history affords a parallel to the deep and bitter enmity of the women of the South. No one who sees them and hears them but must feel the intensity of their hate. Not a man is seen; nothing but women with houses plundered, fields open to the cattle and horses, pickets lounging on every porch, and desolation sown broadcast, servants all gone and women and children bred in luxury, beautiful and accomplished, begging with one breath for the soldiers' rations and in another praying that the Almighty or Joe Johnston will come and kill us, the despoilers of their homes and all that is sacred. Why cannot they look back to the day and the hour when I, a stranger in Louisiana, begged and implored them to pause in their career, that secession was death, was everything fatal…Vicksburg contains many of my old pupils and friends; should it fall into our hands I will treat them with kindness, but they have sowed the wind and must reap the whirlwind…*

*Affectionately yours,*
*W.T. Sherman*

# Three Last Letters

And finally, an excerpt from a letter from Martha Amanda Quillin of Decatur to her cousin, Sarah E. Quillin, whom she wrote to all her life. With her words, she represents the spirit of Southern women who risked it all "for the sanctity of home."

*November 15, 1865, near Decatur, Georgia*

*Heaven forgive me if I prayed that I might never see the destruction, the deep distress, the morn would reveal to me. That too has passed and only lives in memory; but no one I hope will ever expect me to love the Yankees.*

*We are not sorry for anything we have done down here, are not repenting, are not whipped or subjugated or anything of that kind...we contended for every principle of horror and justice and for the most sacred rights—for the sanctity of home...*

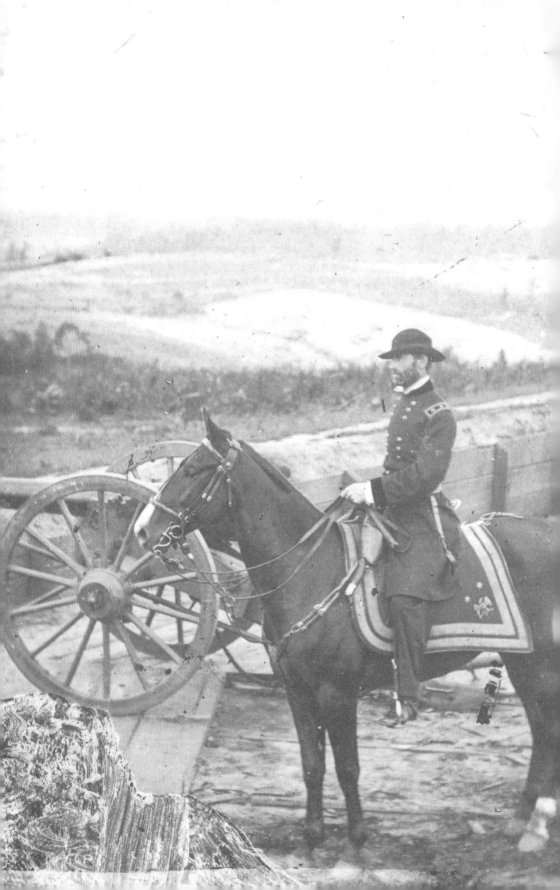

# William Tecumseh Sherman
# The Man and the Myth

*The biggest Yamn Dankee of them all, that shoundrel Scerman—a sud blucker if there ever was one…came riding into town with his taming florches threatening to mike a stratch and turn Bara to the ground!*
—Used with permission from storyteller Betty Ann Wylie's spoonerism spoof called Wone with the Gind

It is not the intent here to provide a complete biographical summary of William T. Sherman's life, but to present some moments and incidents that reveal a more open portrait of the man—his sense of humanity, his ideals, his dedication to family, his flaws and strengths.

The Shermans had been Americans for almost two centuries, since the Mayflower Compact, and had been in Ohio since the early 1800s, having been deeded two sections of land in the Western Reserve (Ohio Territory) as indemnity for property lost in Connecticut during the Revolutionary War. Tecumseh was born in 1820, named after the famous Indian leader, not in honor of his fighting skills, but for his ideas of Indian union. He was known for having a real power for organization, eloquence and self-control. Tecumseh's father, Charles Sherman, said, "I think it is a fine name

to name a little boy—Indian or white." It turned out to be a most appropriate name, foreshadowing what the young "Cump" (the nickname he was called by all) would become and what his name stood for.

Father Charles Sherman was on his way to Lebanon, Ohio, to hold circuit court when taken ill with a fever. His condition quickly deteriorated and he died the next day, leaving a widow with eleven children, between ages one and nineteen, with only a small pension to support her. Their neighbor, Thomas Ewing, wanted to repay a debt to Charles Sherman for help given to him during his own young and difficult days. He offered to take in one of the Sherman children as one of his own. One of the older daughters, Elizabeth, advised him to take in her little brother, Cump, as he was the brightest of the lot. Thus Cump became a "foster child" of the Thomas Ewing family, with only a side lawn separating him from his real family and his foster one.

The Ewings were devout Catholics and, as Cump had never been baptized, that was the first order of business for the seven-year-old. He was given the Christian name of William as it was Saint William's Day, and from that day on, he became known as William Tecumseh Sherman (though family and soldiers under his command continued to call him "Cump").

One of his foster sisters was the young Ellen (Ellie), four years younger than Cump. Father Thomas Ewing was prominent in Ohio politics as a Whig, becoming a U.S. senator and secretary of the treasury under General Benjamin Harrison. His name at one time was bandied about as the vice presidential candidate. In the meantime, Cump went to West Point, was considered to be highly intelligent and graduated sixth in his class. He failed only in neatness of dress and form and in conformity to the rules. After graduation in 1840, he began his army career, was often transferred and discovered his love for painting, and for his foster sister, Ellen.

He described her as one "I have so long loved as a sister" and wrote to her often, with intentions of marrying her. But the army was "a first rate place for the single man but no place at all for a married man, that is unless the wife is willing to forsake and often lose the comforts of civilized life." Besides, he gave a portion of his salary to help support his mother, and Ellen was

used to the civilized, pampered life. So they had an extremely long engagement.

At the age of thirty, William married Ellen. Three years later, with a wife and two children to support, he took a leave of absence from the army and (at the urging of his father-in-law) took up the banking business in San Francisco. He was not much good at it, nor was the bank. Both failed. Then he tried the law, and was admitted to the bar without exam "on the grounds of his general intelligence." Again he was not well suited, so he went back to the army, accepting the position of superintendent of the new military school in Alexandria, Louisiana (eventually Louisiana State University). By then he had four children, with a fifth on the way. Fourth child Thomas was born with a caul over his face. It was said to mean he was born with second sight. Much to his father's chagrin, he later became a Jesuit priest.

Cump was well suited for the superintendent's post, except for the fact that one couldn't hire servants in Louisiana; you had to own them. He refused to invest his money that way. War was brewing and Thomas Ewing did not want his daughter and grandchildren living in the troubled South. When Louisiana seceded from the Union in early 1861, Sherman resigned. He would not fight for the South. "On no account would I do any act or think any thought hostile to or in defiance of the old government of the U.S. After all my family helped frame the Constitution and it is sacred to me."

They moved back to St. Louis and had to live "tight fisted" for a while. Officials from Washington offered him a colonel's commission in the regular army and he accepted. The family moved back to Lancaster, Ohio, as Ellen was expecting child number six. Of the Civil War Sherman wrote, "This is a strange war. We are fighting our own people, many of whom I knew well in earlier years."

As a commander, Sherman began his battle with the press, not allowing any news published from his camp. The press labeled him the "Mad General." His reaction was to treat reporters as if they were spies. Folklore about Sherman as a commander claimed he never slept through the night. He said the quiet of the night offered him the best chance to hear noises at a distance. He would take catnaps during the day, sometimes leaning against a tree,

inspiring untrue comments from soldiers about the general "tiding one over."

It was also said that Sherman was the least pretentious of any of the generals when it came to his appearance and to dress codes, following the pattern he set at West Point. A well-known story tells of a sloppily dressed general who encounters one of his men mercilessly beating a mule that stubbornly refused to be pulled out of the ditch. The general called out, "Stop beating that mule." The soldier looked at the unkempt general, not recognizing him, and said, "Who are you to tell me to stop beating that mule? I'll beat him if I want to." Sherman replied, "I'm General William Tecumseh Sherman and I order you to stop beating that mule." The mule-beater took one look at the general, dressed in an old slouch coat and a weathered dark hat and said, "That story has played out one too many times. Every man wearing an old slouch coat and a dark hat claims to be the general."

After his victory at Vicksburg, Sherman made his camp near Bovina, at a plantation known as Woodburne. He thought this was a good place and time to send for his family, whom he dearly missed. Ellen came with four of the children, including his favorite, son Willy, age nine, who was said to be the spitting image of his redheaded father. They all lived in tents like the soldiers and had a grand time. The 13th U.S. Infantry Regiment made Willy an honorary sergeant, including him in their guard details and parades. He was treated like the miniature version of his father, the commander.

"I have a healthy camp," wrote Sherman to his father-in-law in late summer of 1863, "with no fear of yellow or other fevers." But he spoke too soon, for when the family left together on a steamboat up the Mississippi River in October, Willy was unusually quiet. He had contracted yellow fever and there was nothing they could do. The chaplain asked Willy if he was prepared to die. He said yes, if it was God's will, but he was afraid to leave his father and mother. He died a few days later on October 3.

The grief and guilt Sherman felt over his precious son's death and his irresponsibility in putting his family in danger never fully left him. The family returned to Ohio to bury Willy, but without his father, who had to return to his troops. Sherman wrote Ellen:

# William Tecumseh Sherman: The Man and the Myth

> *I can hardly trust myself. Sleeping, waking, every where I see my poor Willy…Why oh why should this child be taken from us?…I will always deplore my want of judgment in taking my family to so fatal a climate at so critical a period of the year…to it must be traced the loss of a child on whose future I have based all the ambition I ever had.*

A few days later he wrote to a fellow officer:

> *My lost boy…he was my pride and hope of life, and his loss has taken from me the great incentive to excel and now I must work on purely and exclusively for love of country and professional pride.*

Sherman was to comment later on the loss of three sons named Willy to three prominent Civil War leaders: Abraham Lincoln, General William Hardee (CSA) and himself. Lincoln's Willy died of typhoid fever in 1862. Hardee's fourteen-year-old Willy died in 1864 in the skirmish at Bentonville, North Carolina, after convincing his father to let him join the Confederate cavalry. The deaths of their three sons created an unbreakable bond between these three.

Willy was not Sherman's only child lost during the war. Sherman returned home for his daughter Minnie's wedding in 1863. Ellen became pregnant with baby number seven, Charles, who was born before the Atlanta campaign. He died shortly after Sherman presented Savannah as a Christmas present to President Lincoln (or some say as a belated birthday present to his wife, born

---

### Sherman's Letters Home: My Dearest Ellen

This letter was written to his wife on the death of their son, Willy.

*Corinth, MI, October 10, 1863*
*Dearest Ellen:*

*I still feel out of heart to write. The moment I begin to think of you and the children, poor Willy appears before me as plain as life…I see ladies and children playing in the room where Willy died, and it seems sacrilege… Why should I ever have taken you to that dread climate! It nearly kills me when I think of it. Why was I not killed at Vicksburg and left Willy to grow up to care for you…*

*Affectionately yours,*
*W.T. Sherman*

## Sherman's Letters Home:
## My Dearest Ellen

This is part of the letter Sherman sent to Ellen upon hearing of the death of their ten-month-old son, Charles.

*Savannah, January 5, 1865*
*Dearest Ellen:*

*I am so sorry for our great loss and that I was unable to be with you when our dear baby was taken from us…yesterday I got your letter of December 23 and realize the despair and anguish through which you have passed in the pain and sickness of the little baby I never saw…I have seen death in such quantity and in such forms that it no longer startles me, but with you it is different…'Tis well that you realize the fact that our little baby has passed from the troubles of life to a better existence.*

*Affectionately yours,*
*W.T. Sherman*

in October). Sherman never even got to see this sickly son. While on the march, it was impossible for Sherman to receive or to send letters. His whereabouts were a necessary secret. He found out about the death of this unseen son from a newspaper article and from a comment in a letter from his father-in-law that alluded to the death. He wrote Ellen:

*I had hoped he would be spared to us to fill the great void in our hearts left by Willy, but it is otherwise decreed and we must submit…I should like to have seen the baby of which all spoke so well, but I seem doomed to pass my life away so that even my children will be strangers.*

When William Sherman died in 1891, he left detailed instructions to be "buried next to my faithful wife and idolized soldier boy, Willy." Willy had died twenty-eight years earlier, but was never forgotten. General Joseph Johnston, CSA, was one of the pallbearers at Sherman's funeral. In his own words Sherman described his life as "an eventful life lived in passion and pain."

Many Georgians, though, might add that he was a careless man about fire and give him the horns and tail to go with it.

# Bibliography

American Life Histories, Manuscripts from the Federal Writers' Project, 1936–1940. Library of Congress, Manuscript Division, WPA Federal Writers' Project Collection.

Andrews, Eliza F. *The Wartime Journal of a Georgia Girl*. New York: D. Appleton and Co., 1908.

Bailey, Anne J. *War and Ruin: William T. Sherman and the Savannah Campaign*. Wilmington, DE: Scholarly Resources, Inc., 2003.

Burge, Dolly Sumner Lunt. *A Woman's Wartime Journal: An Account of Sherman's Devastation of a Southern Plantation*. Macon, GA: J.W. Burke, 1927.

Burton, Katherine. *Three Generations* [of Ewing Women]. New York: Longmans, Green, and Co., 1947.

Campbell, Jacqueline Glass. *When Sherman Marched North From The Sea: Resistance On The Confederate Home Front*. Chapel Hill: University of North Carolina Press, 2003.

Canning, Nora. "Sherman in Georgia." In *Our Women in the War*, article #15. Charleston, SC: News and Courier Presses, 1885.

Cashin, Edward J. *General Sherman's Girlfriend and More Stories about Augusta*. Columbia, SC: Woodstone Press, 1992.

Clarke, Erskine. *Dwelling Place: A Plantation Epic*. New Haven, CT: Yale University Press, 2005.

Confederate Reminiscences and Letters 1861–1865. Vol. 2. Georgia Archives Collection.

# Bibliography

Cook, Ruth Beaumont. *North Across the River: A Civil War Trail Of Tears*. Birmingham: Crane Hill Publishers, 2000.

Cooper, Miss A.C. "Days That Are Dead." In *Our Women in the War*, article #74. Charleston, SC: News and Courier Presses, 1885.

Cunyus, Lucy Josephine. *History of Bartow County, Georgia*. 1933. Reprint, Greenville, SC: Southern Historical Press, 1983. Available at the Georgia Room in the Cobb County Library.

Davis, Burke. *Sherman's March*. New York: Vintage Books, 1980.

Davis/Quillen Letters. MSS #90F. Kenan Research Center, Atlanta History Center Archives.

Davis, Robert S. Jr. *Requiem Lost City: Sallie Clayton's Memoirs of Civil War Atlanta*. Macon, GA: Mercer University Press, 1999.

Davis, William C., and Bell I. Wiley, eds. *Civil War Times Illustrated*. New York: Black Dog and Leventhal Publishers, 1994.

Doctorow, E.L. *The March*. New York: Random House, 2005.

Fellman, Michael. *Citizen Sherman: A Life of William Tecumseh Sherman*. Lawrence: University of Kansas Press, 1995.

Gay, Mary. *Life in Dixie during the War*. Atlanta: Darby Publishing Co., 1979.

Glatthaar, Joseph T. *The March to the Sea and Beyond*. New York: New York University Press, 1985.

Green, Anna Maria. *The Journal of a Milledgeville Girl*. Edited by James C. Bonner. Athens: University of Georgia Miscellanea Publications, no. 4, 1964.

Haeger, Diane. *My Dearest Cecelia: A Novel of the Southern Belle Who Stole General Sherman's Heart*. New York: St. Martin's Griffin Publishers, 2004.

Harrington, Hugh T. *Civil War Milledgeville: Tales from the Confederate Capital of Georgia*. Charleston, SC: The History Press, 2005.

Henken, Elissa R. "Taming the Enemy: Georgian Narratives about the Civil War." *Journal of Folklore Research* (Department of Folklore and Ethnomusicology, Indiana University) 40, no. 3 (2003).

# Bibliography

Hoehling, A.A. *Last Train from Atlanta*. New York: Bonanza Books, 1958.

Howard, Frances Thomas. *In And Out Of the Lines*. New York: The Neale Publishing Company, 1905.

J., Mrs. L.F. "A Child Wife of 1863." In *Our Women in the War*, article #33. Charleston, SC: News and Courier Presses, 1885.

James, Inez. Arthur C. Ford Papers, Varnell's Station, GA. MSS #112 F. Kenan Research Center, Atlanta History Center Archives.

Jones, Katherine M. *When Sherman Came: Southern Women And The Great March*. New York: Bobbs-Merrill Company, 1964.

Jones, Mary Sharpe, and Mary Jones Mallard. *Yankees A' Coming*. Edited by Haskell Monroe. Tuscaloosa, AL: Confederate Publishing Company, 1959.

Joslyn, Mauriel Phillips, ed. *Valor and Lace: The Roles of Confederate Women, 1861–1865*. Murfreesboro, TN: Southern Heritage Press, 1996.

Kaemmerlen, Cathy. *New Manchester Girl*. Told and adapted by the author. Compact disc. Marietta, GA: Tattlingtales Productions, 2002. www.tattlingtales.com.

Kennett, Lee. *Marching Through Georgia*. New York: HarperCollins Publishers, 1995.

King, Spencer B., ed. "Fanny Cohen's Journal of Sherman's Occupation of Savannah." *Georgia Historical Quarterly* 41 (December 1957).

Knight, Lucian Lamar. *Georgia and Georgians*, vol. 3. 1913.

Koppes, Steven N. "Folklore—Where Fact Meets Fiction," *University of Georgia Research Magazine*, Spring 2000.

Lovett, Howard Meriwether. *Grandmother Stories from the Land of Used-To-Be*. Athens: The University of Georgia Libraries, 1913.

McAllister, Anna. *Ellen Ewing, Wife of General Sherman*. Brooklyn: Benziger Brothers, 1936.

McClatchey, Minerva Leah Rowles. "Journal of Minerva Leah Rowles McClatchey 1864–65." *Georgia Historical Quarterly* 51 (June 1967).

McElreath, Mrs. Walter. Mrs. Walter McElreath Papers. MSS #291F. Kenan Research Center, Atlanta History Center Archives.

# *Bibliography*

Means, Mrs. C.E. "Dear Aunt Kate." In *Our Women in the War*, article #2. Charleston, SC: News and Courier Presses, 1885.

Miles, Jim. *To The Sea: A History and Tour Guide of Sherman's March*. Nashville: Rutledge Hill Press, Inc., 1989.

Morris, Mrs. Lelia C. (Pullen). *Personal Recollections of the War: Girl Confederate Soldiers*. Southern Women Collection, Eleanor S. Brockenbrough Library, Museum of the Confederacy, Richmond, VA.

Myers, Robert Manson, ed. *The Children of Pride: The Story of the Rev. Dr. Charles Colcock Jones of Liberty County and Family Before, During, and After the Civil War*. New Haven, CT: Yale University Press, 1987.

Newton County Historical Society, comp. *History of Newton County, Georgia*. Covington, GA: Newton County Historical Society, 1988.

*Our Women in the War: The Lives They Lived, The Deaths They Died*. Charleston, SC: News and Courier Book Presses, 1885.

Postell, Rosa. "Two Letters: Sherman's Occupation of Savannah." *Georgia Historical Quarterly* 50 (March 1966).

Reminiscences of Confederate Soldiers, United Daughters of the Confederacy. Georgia Department of Archives.

Screven, Cornelia E. "Faithful Old Nancy." In *Our Women in the War*, article #23. Charleston, SC: News and Courier Presses, 1885.

Sherman, William T. *Memoirs of General William T. Sherman*. New York: D. Appleton Co., 1875.

———. *Sherman's Home Letters*. New York: C. Scribner's Sons, 1909.

Simpson, Brooks and Jean V. Berlin, eds. *Sherman's Civil War: Selected Correspondence of William T. Sherman, 1860–1865*. Chapel Hill: University of North Carolina Press, 1999.

Smith, Derek. *Civil War Savannah*. Savannah: Frederic C. Beil, 1997.

Steele, Christy, and Anne Todd, eds. *A Confederate Girl: The Diary of Carrie Berry, 1864*. Mankato, MN: Blue Earth Books, 2000.

Thomas, Gertrude Clanton. Diary and Letter. MSS Division, Duke University Library, Durham, NC.

# *Illustration Credits*

*Pages 16–17:* Three women on front porch. *Courtesy Georgia Archives, Vanishing Georgia Collection, gwn 021.*

*Pages 34–35:* Shell-damaged Potter House in Atlanta. *Courtesy Library of Congress.*

*Pages 58–59:* Refugees loading up wagons at the Atlanta Depot. *Courtesy Library of Congress.*

*Pages 76–77:* Federal encampment on Decatur Street in Atlanta. *Courtesy Library of Congress.*

*Page 94:* Mary Ann Harris Gay. *Courtesy Georgia Archives, Vanishing Georgia Collection, dek 417–85.*

*Page 95:* Barbara McCoy Howell of La Grange. *Courtesy Georgia Archives, Vanishing Georgia Collection, trp 322.*

*Page 114:* William Tecumseh Sherman. *Courtesy Library of Congress.*

Magnolias used with permission of Frank Tarpley.

# About the Author

Photo by Robert M. Gaare.

Cathy Kaemmerlen is a professional actress, dancer, playwright and storyteller known for her variety of one-woman shows and characters. She has developed and performs over thirty in-school programs and her multiple living history shows on various periods of American history, concentrating on the Civil War. A collector of stories, she has traveled and toured widely under the auspices of Young Audiences, the National Women's History Project and the Georgia and South Carolina Arts Commissions. A Hambidge fellow for over ten years (where she writes many of her shows), and featured artist on the Southern Artist Profile of the Southern Arts Exchange, she has produced two storytelling CDs: *Foolish Folk* and *New Manchester Girl*. This is her first published book.

Cathy is Southern born and bred to Yankee parents and is the proud mother of three: Michael (twenty-four), Sara (twenty-two) and Eric (twenty), and wife to Robert Gaare, who owns his own printing business in Marietta, Georgia. Check her out at www.tattlingtales.com.

10/7